Illinois Central College
Learning Resources Center

The Critical Idiom
General Editor: JOHN D. JUMP

23 Dada & Surrealism

In the same series

Dada &
Surrealism/*C. W. E. Bigsby*

Methuen & Co Ltd

First published 1972
by Methuen & Co Ltd
11 New Fetter Lane, London EC4
© *1972 C. W. E. Bigsby*
Printed in Great Britain
by Cox & Wyman Ltd, Fakenham, Norfolk

SBN 416 08150 9 Hardback
SBN 416 08160 6 Paperback

Distributed in the U.S.A.
by Barnes and Noble Inc.

Contents

General Editor's Preface

This volume is one of a series of short studies, each dealing with a single key item, or a group of two or three key items, in our critical vocabulary. The purpose of the series differs from that served by the standard glossaries of literary terms. Many terms are adequately defined for the needs of students by the brief entries in these glossaries, and such terms will not be the subjects of studies in the present series. But there are other terms which cannot be made familiar by means of compact definitions. Students need to grow accustomed to them through simple and straightforward but reasonably full discussions of them. The purpose of this series is to provide such discussions.

Some of the terms in question refer to literary movements (e.g., 'Romanticism', 'Aestheticism', etc.), others to literary kinds (e.g., 'Comedy', 'Epic', etc.), and still others to stylistic features (e.g., 'Irony', 'The Conceit', etc.). Because of this diversity of subject matter, no attempt has been made to impose a uniform pattern upon the studies. But all authors have tried to provide as full illustrative quotation as possible, to make reference whenever appropriate to more than one literature, and to compose their studies in such a way as to guide readers towards the short bibliographies in which they have made suggestions for further reading.

University of Manchester John D. Jump

Prefatory Note

Like others before me in this series I am acutely aware of the peculiar difficulty of describing complex ideas and movements in a book of this length. The brief introductory volume, as Clifford Leech pointed out in his study of tragedy, is often more difficult to write than an extensive analysis. Selection becomes painful and must often be arbitrary; elaborate argument frequently has to bow to critical assertion. For this reason it is essential to stress the introductory nature of this work. I have attempted to suggest where the general reader might most profitably turn next in the bibliography – though this again is necessarily highly selective.

Anyone approaching Dada and Surrealism must acknowledge the invaluable help of those who have preceded him. In this case I must express my gratitude to J. H. Matthews, Robert Motherwell, Maurice Nadeau, Willy Verkauf and Hans Richter.

Part One/Dada

I

Definitions, Statements and Manifestoes

Dada was a literary and artistic movement, international in scope and nihilist in character, which lasted from 1915 until 1922.

(*Encyclopaedia Britannica*)

Dénomination volontairement vide de sens, choisie dans le diction-naire parmi les plus anodines, adoptée par un movement d'art et de littérature apparu en 1916 et qui prétendait, par la dérision et l'irra-tionel, le hasard, l'intuition, abolir société, culture et art traditionnels, pour retrouver le réel authentique.

(Larousse)

The discrepancy in dating demonstrated above is symptomatic of the confusion which surrounds the birth of an artistic movement which seemed both to deny art and to decry the notion of formal movements. The search for origins, the attempt to trace and define this most quixotic of phenomena, has provided futile amusement for academics and artistic speleologists for the last fifty years. There can be few movements, however, which lend them-selves less to solemn exegesis. Indeed, the would-be explicator of Dadaism soon encounters well-prepared defences. Fully alive to the fact that criticism has a tendency to fossilize the vital and the evanescent, the Dadaists took pains to discourage future genera-tions of historians and critics. The Rumanian painter, Marcel Janco, refused to conceive of a valid history; Max Ernst, the German painter and poet, pointed out the impossibility of captur-ing the ephemeral; while Jean Arp ridiculed critical methodology

in an ironical account of the founding of Dada which is a particu-
larly effective satire of ponderous academicism:

> No dadaist will ever write his memoirs! Do not trust anything that
> calls itself 'dada history', however much may be true of Dada, the
> historian qualified to write about it does not yet exist.
>
> (Marcel Janco)

> . . . a Dada exhibition. Another one! What's the matter with everyone,
> wanting to make a museum piece out of Dada? Dada was a bomb . . .
> can you imagine anyone, around half a century after a bomb explodes,
> wanting to collect the pieces, sticking it together and displaying it?
>
> (Max Ernst)

> I hereby declare that Tristan Tzara found the word DADA on
> February 8th, 1916, at 6 p.m. I was present with my five children when
> Tzara uttered this word for the first time – filling us with justified
> enthusiasm. This took place in the Café Terrace in Zurich – I was
> putting a roll into my left nostril at the time. I am convinced that this
> word is not of the slightest importance and that only morons and
> Spanish professors can be interested in dates. What interests us is the
> Dada spirit and we were all Dada before Dada ever existed. The first
> Holy Virgins I painted date from 1886 when I was only a few months
> old and used to amuse myself by pissing graphic impressions. The
> morality of idiots and their belief in geniuses gives me the shits.
>
> (Jean Arp)

Despite their distrust of programmes and their revolt against
formalized systems the Dadaists delighted in publishing numerous
and frequently contradictory statements of their beliefs. While
considering that to define Dada was 'un-Dadaistic' they constantly
attempted to do so, in the process revealing a characteristic pre-
dilection for paradox and contradiction. Thus Tzara could
announce that there should be 'No More Manifestoes' while
devoting considerable time and energy to compiling a large
number of them. But, as he was later to say in one of his poems,
'If each man says the opposite it is because he is right.' It is

scarcely surprising that Max Ernst should have listed Walt Whitman as one of his favourite poets.

The manifesto seemed to answer the public need for direct, polemical statement. Yet, perversely, it served merely to further the Dadaists' aim of taunting the bourgeoisie. For while the public looked for a plain statement of intent, the bare bones of the latest artistic movement, they were caught in a web of words whose primary purpose was to demonstrate the redundancy of language. Nevertheless, though wildly and intentionally contradictory, these statements and manifestoes do serve at least obliquely to convey something of the tone and essence of Dada:

> To be against this manifesto is to be a Dadaist.
>
> ... in principle I'm against manifestoes, as I am also against principle.
> ... I write this manifesto to show that people can perform contrary actions together while taking a fresh gulp of air.
>
> (Tristan Tzara)

> Nothing was holy to us. Our movement was neither mystical, communistic nor anarchistic. All of these movements had some sort of program, but ours was completely nihilistic. We spat upon everything, including ourselves. Our symbol was nothingness, a vacuum, a void. ...
>
> (George Grosz)

> The honorific title of nihilists was bestowed on us. The directors of public cretinization conferred this name on all those who did not follow in their path.
>
> (Jean Arp)

> ... the misunderstanding from which Dadaism suffered is the chronic disease that still poisons the world. In its essence it can be defined as the inability of a rationalized epoch and of rationalized men to see the positive side of an irrational movement.
>
> Over and over again, the strumming, shouting and dancing, the striving to épater le bourgeois, have been represented as the chief characteristics of Dadaism. The riots provoked by Dadaism in Berlin

and Paris, the revolutionary atmosphere surrounding the movement, its wholesale attacks on everything, led critics to believe that its sole aim was to destroy all art and the blessings of culture. The early Dada manifestoes, in which nonsense was mixed with earnestness, seemed to justify this negative attitude.

In the considered opinion of this Manifesto, Dada had both destructive and constructive sides.

(Dada Manifesto, 1949)

Dada was anything but a hoax; it was a turning on the road opening up wide horizons to the modern mind. It lasts and will last as long as the spirit of negation contains the ferment of the future.

(Marcel Janco)

Art demands clarity.... We are fighting the lack of system for it destroys forces.

(Arp, Janco, etc.)

I'm against systems, the most acceptable system is on principle to have none.

(Tristan Tzara)

At Zurich in 1915, uninterested as we were in the slaughterhouses of the world war, we gave ourselves to the fine arts. While the cannon rumbled in the distance, we pasted, recited, versified, we sang with all our soul. We sought an elementary art which, we thought, would save men from the curious madness of these times. We aspired to a new order.

(Jean Arp)

Art is a pharmaceutical product for morons.

(Francis Picabia)

Dada has launched an attack on the fine arts, an enema to the Venus de Milo, and finally enabled 'Laocoon and Sons' to ease themselves after a thousand-year struggle with the rattle-snake.

(Jean Arp)

Art is going to sleep for a new world to be born. 'ART' – parrot word – replaced by DADA ... Art is a PRETENSION warmed by

the TIMIDITY of the urinary basin, the hysteria born in THE STUDIO.

(Tristan Tzara)

Dada hurts, Dada does not jest, for the reason that it was experienced by revolutionary men and not by philistines who demand that art is a decoration for the mendacity of their emotions . . . I am firmly convinced that all art will become dadaistic in the course of time, because from Dada proceeds the perpetual urge for its renovation.

(Richard Huelsenbeck)

Cubism was a school of painting, futurism a political movement. Dada is a state of mind. To oppose one to the other reveals ignorance or bad faith.

(Tristan Tzara)

Dada is German Bolshevism.

(Richard Huelsenbeck)

Do not trust Dada. Dada is everything. Dada doubts everything. But the real Dadas are against DADA.

(Tristan Tzara)

A movement which includes the nihilistic Walter Serner, the effervescent Tristan Tzara and the sober intelligence of Hugo Ball is difficult to categorize. Most of the Dadaists were young men united in a temporary alliance against the past but all were working their own way towards a personal response to art and a world in which personal maturity seemed to coincide with universal dissolution. Hugo Ball, who founded the Cabaret Voltaire in Zurich, defined the purpose of his venture as an attempt to 'draw attention across the barriers of war and nationalism, to the few independent spirits who live by other ideals'. Although by degrees the Dadaists did formulate more specific objectives it is worth bearing in mind that their primary emphasis was laid on the need for individual freedom in a time of political, moral and aesthetic crisis. This is the core of Dada – the foundation of all that was to follow.

2
The Spread of the Dada Virus

The war of 1914–18 was for many final proof of the bankruptcy of a whole intellectual, cultural and social system. Religion, rational thought, humane values seemed implicitly contradicted by the slaughter initiated by Europe's civilized nations and all too often condoned by intellectuals and artists as well as politicians and militarists. Yet while Verdun and Ypres provoked a crisis of faith for many, the disintegration of traditional values and assumptions had predated the specific evidence of the battlefield. In the age of Darwin, Marx, Freud and Einstein, the true scientist, the true engineer, the true artist, and, by implication, the true man, was an iconoclast. As Ibsen remarked, the artist's function was 'to move the boundary posts'.

In painting, impressionism paved the way for more radical experimentation. Cézanne challenged the mimetic principle only to be superseded by a group of artists who seemed to confront tradition so directly that they earned themselves the title of 'wild beasts' – Les Fauves. They in turn were followed by the Cubists and to a lesser extent the Futurists – artists who finally fractured a mode of thought which had dominated painting for centuries. Distrusting rationality they turned to the unsophisticated art of Africa, finding there both a naïve directness and a structural technique which they saw as releasing them from a slavish adherence to the 'real' world. Suspicious of a methodology which seemed ill-equipped to capture the essential truth of the modern

world they set out to forge their own instruments and by doing so came close to changing the nature of that truth.

In literature the symbolists sought to explode the surface of life, captured so precisely by the naturalists, in order to conjure up the imperceptible sub-world of the unconscious. They tested language and found it wanting. They sought in intuitive perception an insight denied to the literal mind. Meanwhile a writer like Alfred Jarry sought to catapult the bourgeois audience out of its stable and comfortable self-assurance by a direct assault on its conviction that art and good taste are indissolubly wedded.

It was against this background that Dada made its appearance. Although at first little more than a collection of *avant-garde* writers and artists who were revolted by the war and suspicious of the role which art and literature had come to play, the Dadaists gradually assumed a consciously subversive role. They ridiculed conventional taste and deliberately set out to dismantle the arts, not in any mood of formalist inquiry but in a desire to discover the point at which culture had become infected with a tainted morality and to detect the moment at which creativity and vitality had begun to diverge. It was thus from the very beginning both destructive and constructive; both frivolous and serious. As Hugo Ball explained, 'What we call Dada is foolery, foolery extracted from the emptiness in which all the higher problems are wrapped, a gladiator's gesture, a game played with the shabby remnants ... a public execution of false morality' (Richter, p. 32). The dissection of the arts which the Dadaists conducted, the reduction of poetry to phonetics, of music to elemental sound, and of art to planes, angles, colours and simplicity of line, was only partly a reflection of the general dissolution which characterized the age. It was also an attempt to purge them of stylistic and ethical accretions which had concealed purity of line and moral purpose alike. The discovery, by writers like Tzara and painters like Arp, of the significance of chance as an active principle, quite free of social and

B

cultural necessities and liberated from the conditioned response of logic and reason, protected this purity even from the potentially crippling influence of the conscious artist himself. Dada, in other words, was simultaneously both art and anti-art; it despaired of contemporary society and despised its attenuated art and yet remained committed to restoring some essential quality missing from both. It is scarcely surprising that Hugo Ball ended his life as a staunch and even saintly Catholic while others later flirted with the communist party. As Hans Richter has suggested, it is precisely these tensions which gave Dada its particular quality of vitality and purpose. But by the same token these tensions were also evidence of divisions which were eventually to open up and destroy the movement.

Dada did not spring into being overnight, nor were its parents entirely unknown. In some ways it was a part of that artistic re-examination which spawned such schools as impressionism, cubism, futurism and, more exotically, suprematism, rayonism, plasticism, vorticism and synchronism. Although Picabia was to call cubism 'a cathedral of s—' and Huelsenbeck was to deny the significance of futurism, both left their mark on Dada. Indeed many of those associated with Dada had been attracted by one or more of these earlier movements: Huelsenbeck and Ball by expressionism, Arp by cubism and Tzara by futurism. The shock tactics, the constant resort to polemic, the experiments with 'sound music' and 'simultaneous poetry', which came over a period to characterize the Dadaists, were not new. As Richter rightly acknowledged 'we had swallowed Futurism – bones, feathers and all' (Richter, p. 33). Yet while the Dadaists rejected what they saw as the banality of naturalism and the anthropomorphic arrogance of romanticism they also came in time to distrust the very modernism from which they emerged.

The exact hour and date of Dada's birth is an open question. Because it was, as its adherents never tired of repeating, a state of

mind rather than a movement, it 'existed' before its official birth in February 1916, and survived its official death, formally pronounced in Germany in 1922. As Marcel Duchamp has said, 'Dada is the nonconformist spirit which has existed in every century, every period since man is man' (*Cinquant'Anni a Dada*, p. 27). And in a sense it is as appropriate to begin a study of Dada with Marcel Duchamp as with anyone for he embodied many of its central tenets long before Huelsenbeck, Ball or Tzara discovered the word in a French/German dictionary as Jean Arp stuffed a roll into his left nostril.

After achieving both success and notoriety with his basically cubist picture *Nude Descending a Staircase*, which scandalized the organizers of the 1912 Salon des Indépendants exhibition in Paris and attracted huge crowds to the Amory Show held in New York in 1913, Duchamp 'abandoned' painting. It was a Dada gesture while Dada itself was still in the womb. Rejecting painting as merely a visual exhibition of craft, he created his *Large Glass*, produced a number of 'ready-mades' and then, with a famous and significant gesture, retired to play chess for the rest of his life. The ready-mades were simply objects which he himself had selected as being commonplace: *A Bicycle Wheel* (1913), *A Bottle Rack* (1914) and, with admirable bad taste, a urinal called *La Fontaine* (1917). These were anti-art gestures, mocking the whole idea of taste and form. They were in the same spirit as his mischievous exercise in demythologizing, *LHOOQ*. This consisted of a picture of the Mona Lisa with added moustache and beard. The new title, when pronounced in French, reduced enigma to erotica and destroyed the mystique of the masterpiece.

In a sense the ready-made is inherently ironical – the logical culmination of representational art. Yet it was never intended to be a 'work of art' for aesthetic appreciation. Since Duchamp's idea of what he called a 'reciprocal ready-made' was a Rembrandt used as an ironing board it is difficult to mistake his purpose, while the

urinal submitted to the Independents Exhibition would presumably challenge even the most abstruse of art critics. Clearly it is possible to see positive elements in work which poses questions about the nature of art, the role of the artist and the essence of taste, as indeed in his further experiments involving the role of chance (in *Three Standard Stoppages* he dropped three pieces of thread a metre long and then preserved the resulting shape) but his resolute withdrawal from art underlined his own sense of betrayal and disillusionment. The 'ready-made' was not simply an anti-art gesture. It was a challenge to a system of values. The positive value of *objets-trouvés*, as seen by the Chinese, the Japanese and later by the surrealists, was not lost on Duchamp. But, in place of the smooth stone or the evocative piece of wood he deliberately chose functional products of his own age, inviting the public to distinguish between these and the art which he saw as drained of energy and imaginative power.

When the war came to France he secured exemption because of a heart complaint but felt ill at ease in an atmosphere of increasing chauvinism and left for New York in 1915. The war also dislodged another putative Dadaist from France – a bizarre exhibitionist called Arthur Cravan who published a small magazine in Paris from 1912 to 1915 which went under the title, *Maintenant*. This was frequently used to attack the aesthetic basis of modern art, though in truth it usually reflected its editor's personal prejudices more than anything. With the onset of war he too removed himself from France, pausing briefly in Spain for an inexplicable yet characteristically disastrous boxing match with the champion boxer, Jack Johnson. Carrying his bruises he, like Duchamp, now set sail for New York, a city which, while not exactly giving birth to Dada, did suffer an impressive hysterical pregnancy.

America had never really been in the vanguard of art nor even fully aware of European developments. But the perception and energy of one man had assured an immediate response to the

modern movement. Alfred Stieglitz, a pioneer in the art of photography, staged a number of exhibitions at 291 Fifth Avenue. It was here that the first American exhibitions of Matisse, Cézanne, Rousseau, Picasso and Picabia were held. Picabia was another ex-patriate 'carrier' for Dada and in Stieglitz's magazine, *Camera Work*, he, like Duchamp before him, was responsible for what were essentially Dada gestures. In one issue he announced a new movement called 'amorphism' which was represented by pictures consisting of nothing but a fraudulent signature. When Stieglitz launched the successor to *Camera Work, 291*, it was natural that Picabia should produce the illustrations – one of which, in a mode reminiscent of Duchamp, was a spark plug bearing the ironical title, 'A Young American Girl in a State of Nudity' – an implicit attack not merely on art but also on the mechanically obsessed futurists.

With the arrival in 1913 of Picabia and subsequently of Marcel Duchamp, the composer Edgar Varèse and the Swiss painter Jean Crotti, New York became a vital centre of what would later have been called Dada activity. But despite the apparently anti-art bias of these artists they failed to formalize their activities. Their provocations were individual gestures rather than aspects of a broader and co-ordinated strategy. Lacking the unifying influence of a Tristan Tzara, who was to become the chief publicist and backbone of Zurich Dada, they were content to poke occasional holes in the fabric of American art. Accordingly, in 1917, Duchamp submitted his urinal to the Independents Exhibition staged at the Grand Central Gallery, and Arthur Cravan, drunk to the point of incoherence, attempted to deliver a lecture. Although frustrated in his attempt to strip and able only to gasp out a few well-chosen obscenities, he and the Dadaists in later years claimed this as a major victory for Dada. Be that as it may, Cravan's subsequent disappearance in Mexico, like Duchamp's grand gesture of renunciation and the suicide of the influential but largely

unproductive Jacques Vaché, crowned his significance for the Dadaists, as he pursued his dissatisfaction with art and society to its logical conclusion.

Duchamp, for his part, joined with Man Ray, the only major American painter at that time to be infected with the Dada spirit, to publish two appropriately ephemeral magazines, *Rong Wrong* and *The Blind Man*, and continued to produce ready-mades. One such, entitled *Combs* and dated February 17, 1916, actually antedated by just nine days the alleged founding of Dada in Zurich.

Like New York, Zurich was a neutral city and an international city. These two facts explain something of the tone of the Dada movement. Its participants were drawn from all parts of Europe: Tristan Tzara and Marcel Janco came from Rumania, Jean Arp and Francis Picabia from France, Hugo Ball, Richard Huelsenbeck, Emmy Hennings and Hans Richter from Germany, Walter Serner from Austria, Marcel Slodki from the Ukraine and Sophie Taeuber from Switzerland. They were, largely, persons who refused to embrace the narrow nationalism of their day at a time when internationalism was considered subversive. As individuals they were increasingly suspicious of social and artistic values which sanctioned or at best tolerated the brutality of war and the solipsism of art. But lacking a programmatic system, they only gradually formulated the anti-art attitude which came, in many people's minds, to typify Dada. Indeed in the early days they tended to identify closely with abstract art.

In February 1916, Hugo Ball, the German poet, organized an artists' cabaret at the Meierei bar, Zurich. Renamed the Cabaret Voltaire it rapidly became a centre for artists and writers, a genuine meeting-place for the arts. It was no accident that Voltaire should have been so 'honoured', though perhaps the choice of name was not without ambiguity. After all, while Voltaire had consistently attacked what he saw as a persecuting orthodoxy, his tastes in literature were extremely conservative. Indeed he saw poetry as

merely an ornament for reason – a quality which the Dadaists came to despise as sterile and inhibiting. At first the Cabaret was a purely eclectic affair, scarcely Dada in intention or mood. Thus Ball decorated the room with paintings and sketches supplied by fauvists, expressionists, cubists and futurists, while staging recitations of the work of Rimbaud, Apollinaire, Jarry and Laforgue, performances of Russian balalaika music, dancing by Sophie Taeuber and singing by Emmy Hennings. Even the first Dadaist publication, a periodical named after the Cabaret Voltaire and published in mid-1916, still contained a wide range of writers and artists including Picasso, Modigliani, Kandinsky, Marinetti, Apollinaire and Cendrars as well as Arp, Tzara, Heulsenbeck, Janco and Ball. Nevertheless, it was in this publication that the word 'Dada' first appeared in print, and already it was clear that while lacking a genuine sense of direction the Dadaists were looking for a rationale which went beyond a simple admiration for the modern.

Huelsenbeck claims to have discovered the word Dada in a German-French dictionary while he and Ball were looking for a stage name for Madame Le Roy, a would-be singer at the Cabaret. Slipping a paper-knife into the dictionary, in a reliance on chance which would have earned the applause of their colleagues, they came across the word which is baby-talk for a horse. They immediately adopted it as the watch-word of the Cabaret and applied it indiscriminately to their performances. This, however, is not the only version of the naming ceremony and since Dada is also Rumanian for 'yes, yes' and, apparently, Kru African for the tail of a cow, it is politic not to inquire too closely into the genesis or etymology of a word which soon acquired a potent meaning of its own.

By 1917 Dada was becoming more clearly defined. Tzara, Huelsenbeck and Janco recited what they called 'simultaneous poems' – poems to be recited by several voices simultaneously –

while Tzara devised poems from the chance juxtaposition of words cut from a newspaper and scattered on the ground. Although their work was to some degree derivative they were now launched on a programme of provocative anti-art gestures which were to become an essential part of Dada. While they continued to display a degree of eclecticism in art, the recitation of French poetry tended to be replaced by acts of Dada provocation. Audiences visiting the Cabaret Voltaire were now less likely to be regaled by bala-laika music and Rimbaud, than by a cacophony of bewildering sounds and 'music'. Georges Hugnet has described one such per-formance which actually took place as late as 1919 and constituted the climax of Dada activity in Zurich, but which none the less typified the exuberant mood of the earlier experiments: 'On the stage keys and boxes were pounded to provide the music, until the infuriated public protested. Serner instead of reciting poems, set a bunch of flowers at the foot of a dressmaker's dummy. A voice, under a huge hat in the shape of a sugar-loaf recited poems by Arp. Huelsenbeck screamed his poems louder and louder, while Tzara beat out the same rhythm crescendo on a big drum. Huelsenbeck and Tzara danced around grunting like bear cubs, or in sacks with top hats waddled around in an exercise called 'noir cacadou' (Nadeau, pp. 56–57).

The Dadaists were also active in the publishing field. Both Tzara and Huelsenbeck published a number of books and the ubiquitous Picabia issued an edition of his peripatetic journal, *391*. Between July 1917 and May 1919, four issues of a periodical called *Dada* were published. As its subtitle 'Literary and Artistic Mis-cellany' reveals, its first numbers continued to demonstrate a considerable catholicity, so that the ironic overtones of the sub-title were not immediately apparent. It was not until the third issue in fact, in December 1918, that the magazine was really dominated by the Dada spirit. As Hugnet has pointed out, the Zurich movement was essentially fostered by writers. The painters

were still largely under the influence of the cubists and futurists, thus potentially compromising the developing anti-art philosophy of men like Ball, Huelsenbeck and Tzara. Nevertheless, when the Cabaret Voltaire closed its doors, the citizens of Zurich having failed to appreciate the activities of the group which had set up its headquarters across the street from Lenin's house, Ball and Tzara opened the Galerie Dada in the middle of the town in March 1917. Here their previous activities continued together with exhibitions of art; Ball, Tzara, Janco and Hans Richter organizing tours of the gallery in which the inquisitive public was alternatively enlightened and insulted. But though Dada constantly threatened to spill over from the cabaret stage and art gallery into public life it never made that connection with revolutionary activity on a political and social plane which was to typify its role in Germany. False and provocative statements were released to the Press, subversive ideas were promulgated in manifestoes, but political action seemed to imply public responsibility and moral involvement of a kind irreconcilable with the Dadaist stance.

The Dada 'bacillus' (so called by Hans Richter) was taken to Germany by Huelsenbeck where it rapidly became radicalized. In New York and Zurich the political scene had been stable. In a Germany sapped by war and torn by sectional strife its revolutionary stance assumed a political purpose. Franz Jung, a Dada associate who later founded the Rhineland Communist Party, made his name by highjacking a German freighter in the Baltic in 1923 and sailing it to Petrograd; Johannes Baader scattered pamphlets nominating himself for president at the ceremony inaugurating the first German Republic; Wieland Herzfeld and Johannes Baargeld both joined the party. In a declaration signed by Raoul Haussman and Richard Huelsenbeck the Berlin Dadaists announced as their aim the international revolutionary union of all creative and intellectual men and women on the basis of radical communism. But Dada, which had witnessed and deplored the consequences

of political engagement, did not succumb quite so easily to the blandishments of left-wing politics. Thus the very same document which seemed to endorse a union of art and politics went on to call for the introduction of the simultaneous poem as a communist state prayer and the immediate regulation of all sexual relations according to the view of international Dadaism. In truth Huelsenbeck remained profoundly suspicious of a party which even then seemed to threaten the individual freedom so essential to Dada, and successfully devalued his support in the very act of pledging his allegiance.

Once born, Berlin Dada became a fairly cohesive group, attracting men of the stature of the caricaturist George Grosz, whose own political proclivities aptly underline the radical aspect of German Dada. (Inevitably both Grosz and John Heartfield, the master of photomontage, later used their talents to expose and ridicule the Nazis.) Yet to some degree the political element had less to do with the essence of Dada itself than with the inter-action between a revolutionary artistic movement and an insecure political structure. Thus, activities which would have been regarded as harmless pranks in Switzerland assumed a politically subversive appearance in Berlin. When a group of Dadaists distributed copies of a periodical called *Every Man His Own Football* they were arrested and charged with bringing the armed forces into disrepute and distributing obscene literature – two charges closely allied in the official mind. The publication itself was banned as were numerous other Dada magazines with titles like *Die Rosa Brille* (Rose-Coloured Spectacles), *Der blutige Ernst* (Deadly Earnest), *Die Pleite* (Bankrupt), *Der Gegner* (Adversary) and *Die Pille* (The Pill).

German Dada was by no means limited to Berlin. There were two flourishing colonies in Cologne and Hanover. In Cologne Johannes Baargeld and Max Ernst published *Der Ventilator* which combined artistic and social iconoclasm to such effect that the

British occupational forces rapidly closed it down. Together with Jean Arp these two organized the famous Dada event in which the public were invited to enter the 'gallery' through the toilet of a beer parlour. In Hanover the Dada banner was carried by a single individual who created his own distinctive brand of revolt. Kurt Schwitters created huge collages, the best known being the one which, with an almost organic capacity, expanded through his house, ejecting tenants and dominating his existence. In a sense his work was tangential to mainstream Dada, and Huelsenbeck's refusal to allow him to join the Dada Club was perhaps less evidence of personal animosity than a recognition of essential differences between them. Schwitters lacked the irony which is fundamental to Dada – being passionately committed to his art. Where others used the collage as an anti-art gesture he was committed to its validity as an art form. The fact that he felt obliged to provide his own meaningless title for his work (MERZ, derived from the word COMMERZBANK) is indicative both of his connection with the Dadaists and of his, perhaps more significant, differences.

The German version of Dada did contribute some original elements, especially in the form of the optophonic poem and the photomontage. The former was simply an attempt to express typographically the fact that a poem 'is an act of respirations and auditive combinations, firmly tied to a unit of duration'. Haussman used letters of varying sizes and thicknesses so that the printed poem took on the appearance of a musical score. The photomontage consisted of a collage of photographs. Like the Rayogram (a photographic process devised by Man Ray) it was a joke at the expense of realism. The camera had supposedly supplanted the realistic painter and yet as John Heartfield and Man Ray demonstrated this too could be subverted. At the same time by bringing together apparently disparate material they were restating the Dadaist belief in simultaneity – the simultaneous existence of

different levels of experience. The contingent realities thus brought into direct relationship obviously created the potential for irony and thus for satire and, in the hands of Heartfield, Dada did indeed become a savage weapon exposing and ridiculing inhumanity, a fact which itself suggests a positive element always present in it.

The export of Dada to Germany had had to wait until virtually the end of the war. It had duly appeared in Berlin at a time of actual revolution and social dislocation; it went into decline and was formally buried as the revolutionary spirit with which it had been so closely identified was itself extinguished.

Dada's arrival in Paris, meanwhile, had coincided with its decline in Zurich. Leaving Switzerland, Tzara had joined Picabia in France, thereby introducing the germ to yet another country. Paris was a natural home for Dada. Its attack on reason, logic, language and bourgeois provincialism was firmly in the new tradition established by Baudelaire, Mallarmé, Rimbaud and Jarry. The surprise was that the *avant-garde* had never previously cohered in an outright assault on social and artistic values on the New York, Zurich and Berlin pattern. In part this was a result of the war, in part a result of the departure of Duchamp and Cravan, and in part a consequence of the lack of any one individual with the verve, audacity and compelling personality of a Tzara. More fundamentally, however, Paris was still largely dedicated to a modernism which the Dadaists increasingly suspected of revisionist tendencies. Reviews like Birot's *Sic* (1916) and Reverdy's *Nord-Sud* (1917–18) were modernist in tone, as was *Littérature*, founded in 1919 and edited by Louis Aragon, Philippe Soupault and André Breton. Despite the apparent irony of the title it was by no means a truly Dada publication on its first appearance. Nevertheless all three had shown their interest in Dada by contributing to the Zurich magazine, *Dada*, and when in 1919 the movement acquired a martyr, in the person of Jacques Vaché, and a publicist in the form of Tristan Tzara, who contributed to the second issue of *Littérature*, the

infection of the *avant-garde* with the dada spirit was complete. Although its editors continued to cast widely for contributors, by December 1919, *Littérature* was ready to sponsor a Dada provocation of a kind which was to characterize Dada's brief and significant appearance in France, and by May it was completely committed to Dada.

The publication, in February 1920, of the *Bulletin Dada* (*Dada* No. 6) merely confirmed the fact that in a few months Paris had become the main centre for Dada activity. This was, anyway, by now merely one of the growing number of Dada publications which included Picabia's *Cannibale* and *391*, Éluard's *Proverbe*, Dermée's *Z*, Tzara's *Dadaphone* (*Dada* No. 7) and *Le Coeur à barbe*.

Paris Dada differed from that found in Berlin and to a degree from that which had flourished in Zurich both in its literary emphasis – the painters becoming increasingly suspicious of its anti-modernism – and in its wholesale commitment to provocation. In a sense it was Dada seen in a mannerist phase. The *Littérature*-sponsored *Premier Vendredi de Littérature*, which was held at the Palais des Fêtes in January 1920, was used to launch an all-out assault on the public as was a subsequent reading of manifestoes at the Salon des Indépendants, while the zenith of Dada activities in Paris was achieved when the crowd at a Dada festival pelted the performers with eggs and, if reports are to be believed, beefsteaks.

Alive to the impossibility of repeating such a 'triumph' of provocation the Dadaists now planned new ventures. Their designs for an 'excursion' to places of no historical interest were ruined by torrential rain but the notion of a public trial of Maurice Barrès, a particularly appropriate target who had exulted in the war, was eagerly pursued. It was this trial, however, which revealed strains in the apparent and always illusory unity of the Dadaists, although these did not resolve themselves into really radical divisions until André Breton proposed a Congress of

Paris, to be held early in 1922, whose prime objective was to be an attempt to examine the plight of modernism. Tristan Tzara accepted, but only on the understanding that the real purpose of the Congress should be to debate whether a railway engine was more modern than a top hat. In other words he accepted on the understanding that he could deflate a project which Breton, in an un-Dadalike manner, seemed determined to take seriously. Paris Dada then collapsed in an orgy of accusations, pamphlets, ex-communications and resignations. Breton broke with Tzara while he in turn engaged in vituperative debate with Picabia. The climax came when Breton physically assaulted the performers at a Dada evening (*Soirée du coeur à barbe*, July 1923) and together with Aragon and Éluard was dragged from the theatre. By now it was evident that the small group who had met in Weimar in May 1922 and who had declared the death of Dada as a movement, had been right. For although as a state of mind it could not die, as an organized assault on the public consciousness and as a resolute enemy of perverted social and artistic values it had outlived its usefulness. The edge had gone from its rhetoric and the public, as ever, had adjusted to its idiom and now expected provocation and absurdity as standard fare. What had once shocked and stimulated now merely amused, while internecine struggles provided evidence of a growing introversion.

3
The Dada Essence

Dada emerged into a world which had already lost its secure faith in absolutes. Confronted with mechanical processes and biological determinism, the individual saw less and less scope for action. While growing industrialism seemed to indicate, in pragmatic terms at least, that the idea of progress was a reasonable premise, the political and social stresses which it released suggested fundamental anomie. Increased wealth clearly did not breed independence and virtue; neither, as became rapidly apparent, did it diminish the rapacity of nation states. Realpolitik was scarcely evidence of rationality and natural justice. Many detected what they took to be an urge towards dissolution (a notion later schematized by Spengler) while Freud's *Interpretation of Dreams*, published in 1900, seemed to cast doubt on reality itself.

In a sense the cubists and futurists were responding to this break-up of a reality which had hitherto been accepted as an article of faith. Cubism unconsciously reflected a state of flux – an internal stress and movement invisible on the surface. And although the futurists perversely glorified a mechanical age, in doing so they recognized a profound change in our perception of the role of the individual and the limitations of human freedom. They exulted in a functional world but at least recognized its functional nature. Yet, like the naturalists, they could not entirely break with the need for a reassuringly ordered view of reality. The naturalists stressed the anarchic impulses at work on the individual only to reveal a new faith in inevitable process; the cubists and futurists sought a higher order in the complexities of geometric and

mathematic insights and the dynamism of vital form. It was finally left to the Dadaists, who emerged in the middle of a brutal war, to reflect accurately a growing sense of absurdity – of the fragmented nature of reality and the total overthrow not only of reason and traditional modes of thought but of faith in an existence dominated by order and accurately expressed by a precise and systematic language. Thus, despite its apparent illogic, Huelsenbeck's poem aptly named 'The End of the World' has a disturbing logic of its own:

This is what things have come to in this world
The cows sit on the telegraph poles and play chess
The cockatoo under the skirts of the Spanish dancer
Sings as sadly as a headquarters bugler and the cannon lament all day
That is the lavender landscape Herr Mayor was talking about when he
 lost his eye
Only the fire department can drive the nightmare from the drawing-
 room but all the hoses are broken.

<div style="text-align: right">(Richter, p. 53)</div>

Yet paradoxically, there was something positive at the heart of their revolt. While they were in a sense merely living out the absurdity of their age, they were also expressing certain values in their work. They saw some point in objectifying anomie. They were not merely pulling down artistic derelicts in order to provide room for new foundations; they were providing a useful antidote to what they took to be defunct social and artistic assumptions. In place of an arrogant anthropomorphism, they offered anonymity (an ideal which, admittedly, they failed to achieve). For a false sense of order and purpose they offered their conviction of a revealed disorder. They challenged our ideas of art, poetry and music and carried their opposition to an apathetic and potentially dangerous bourgeoisie to a logical conclusion. They were not afraid to denounce the war, frequently, at times and in places where it was dangerous to do so. They resolutely attacked specious

morality and outrageously flouted standards of taste and conduct which seemed to them arbitrary and outmoded. They ridiculed the conception of established structures in society as they had the idea of tradition in art. They wanted no more masterpieces and no more unquestioned allegiance to the state, for they saw both as deadly to the survival of artistic and social life. Dada was, in part at least, a lesson in humane values. It was also of course a haphazard collection of contrary impulses which at times expressed little more than the vitality and mischievous humour of its creators. But these, too, are positive qualities, especially when seen against a background of a world enervated by war and adjusted to respectable solemnity in art.

There were to be no more masterpieces partly because the art of one generation must never be allowed to determine that of the next but more fundamentally because such a regard for the past implied a static set of values and in their eyes granted validity to irrelevant criteria. If life was characterized by flux, if it was dominated by evanescence, then logically the ideal work of art was that exemplified by Picabia's picture which Duchamp erased as it was created. This was one reason why Max Ernst was appalled by the prospect of a Dada exhibition many years later. For, as he asked, how can you hope to capture the explosion of a bomb fifty years after it has been detonated. To view Dada within the walls of a museum or between the covers of a book is to defuse it, to deny its subversive character and vital form.

The Dadaist recognized no arbiter but himself because he saw no one whose values were to be trusted. Moral judgements are clearly difficult to justify at a time when formal ethics are being rallied under a dozen banners for the sake of national aggrandisement; aesthetic judgements make little sense when form, structure and content are undergoing profound change. Thus Dada's apparent lack of values, its refusal to acknowledge terms such as 'good' and 'bad', was neither an indication of nihilism nor proof

c

of anarchism but a sensitive reflection of an age which had no trust in the old dogmas and yet had equally failed to discover a new faith. What faith could one have for example in a religion which compromised itself in the cause of national ambition? What trust could one place in the idea of justice, progress and purpose when these were daily exposed as frauds? As Hemingway's hero in *A Farewell to Arms* remarks, 'I was always embarrassed by the words sacred, glorious, and sacrifice and the expression in vain ... for a long time ... I had seen nothing sacred and the things that were glorious were like the stockyards at Chicago if nothing is done with the meat except to bury it. There were many words that you could not stand to hear and finally only the names of places had dignity ... Abstract words, such as glory, honour, courage, or hallow were obscene beside the concrete names of villages, the numbers of roads, the names of rivers, the numbers of regiments and the dates' (*A Farewell to Arms*, pp. 84–5). The Dadaists shared this distrust.

If language had been devalued by its abuse in war it also operated as a reactionary influence in itself – failing to reflect the Dadaist's sense of mutability and working to undermine his freedom and originality. As Breton remarked: 'In addition to the constraints of art, ordinary language is "the worst of conventions" because it imposes upon us the use of formulas and verbal associations which do not belong to us, which embody next to nothing of our true natures; the very meanings of words are fixed and unchangeable only because of an abuse of our power by the collectivity.' Language had become a barrier rather than a bridge and even the idea that it could facilitate communication and thus valid relationships was dismissed by Breton as 'a monstrous aberration' (Motherwell, pp. xxvii–xxix).

There was nothing particularly original in this notion of an exhausted and prescriptive language. Mallarmé had dedicated himself to giving 'a purer meaning to the words of the tribe' ('Le

Tombeau d'Edgar Poe'), while in 1912 the futurists, through the person of Marinetti, had proposed to go one better than free verse by employing *parole in libertà* – free words. But where they called for the abolition of punctuation, the adverb, and the adjective, and rejected all syntax, they did so in order to impose a new orthodoxy, insisting that the verb must be used in the infinitive and that every substantive must have its double – must be linked, in other words, without the blessing of conjunctions, with the substantive to which it is analogically joined (man-destroyer, door-tap, square-funnel). The Dadaists were not so restrictive. They wanted, in Jean Arp's words, to capture 'the language of light' (p. 49) – to make people alive to the creative possibility of language shorn of its burden of definitive meaning. They wished to charge the word with a new energy. As Hugo Ball insisted, 'We should withdraw into the inner alchemy of the word, and even surrender the word; in this way conserving for poetry its most sacred domain. We should stop making poems second-hand; we should no longer take over words (not even to speak of sentences) which we did not invent absolutely anew, for our own use. We should no longer be content to achieve poetic effects with means which in the final analysis are but the echoes of inspiration' (Motherwell, p. xx). Hugo Ball's response was to abandon words entirely, together with their cerebral content, concerning himself with the basic elements of language – sound, intonation, rhythm:

> gadji beri bimba glandridi laula lonni cadori
> gadjama gramma berida bimbala glandri galassassa laulitalomini
> gadji beri bin blassa glassala laula lonni cadorsi sassala bim
> Gadjama tuffm i zimzalla binban gligia wowolimai bin beri ban.
>
> (Richter, p. 42)

It was his intention that with these sound poems he should denounce a language 'ravaged and laid barren by journalism' (*Ibid*, p. 42). In this he was joined by Kurt Schwitters, who was appalled

when someone detected a recognizable word in one of his works. Although achievement in this direction was not always very impressive their determination to breathe life into words which they saw as encrusted with age and distorted by polemicists and publicists can be seen as evidence of their positive qualities. As with so many Dada experiments, what appears at first to be simply a bizarre and self-indulgent gesture is ultimately fascinating for its implications, as it serves to pose questions about the nature of both language and poetry which are not without interest and justification.

In other experiments the Dadaists created poems from words picked out of a hat – a kind of verbal collage relying on the intervention of chance for freshness, spontaneity and illogical juxtaposition. The same technique was applied to painting, particularly by Duchamp. They also pursued the futurists' experiments with 'simultaneity', Huelsenbeck, Janco and Tzara on one occasion reciting the 'simultaneous poem', 'L'Amiral cherche une maison à louer'. This consisted of three separate texts recited simultaneously. The texts themselves were performed in three different languages, with parts consisting simply of rhythmic noises. Tzara acknowledged his debt to the work of Marinetti and Barzun as well as to the speculations of Mallarmé and Apollinaire but at the same time the simultaneous poem did reflect a specifically Dada response to existence. It was a poem which re-enacted what Huelsenbeck called 'a sense of the merrygoround of things'; it demonstrated the Dadaists' conviction that life does not consist of logical and sequential events but a bewildering and disordered simultaneity. Hugo Ball, taking things a stage further, has said that the 'subject of the *poème simultané* is the value of the human voice. The vocal organ represents the individual soul, as it wanders flanked by supernatural companions. The noises represent the inarticulate, inexorable and ultimately decisive forces which constitute the background. The poem carries the message that mankind is swallowed up in a mechanistic process. In a generalized and com-

pressed form, it represents the battle of the human voice against a world which menaces, ensnares and finally destroys it, a world whose rhythm and whose din are inescapable' (Richter, p. 31). These claims are clearly not without their irony, for while plausible enough they have a suspicious echo of tendentious art criticism. Yet Ball was concerned with offering a radical change in poetry to parallel that in pictorial art. His 'abstract poetry' abandoned the word as abstract painting had in turn abandoned the representational object. It was Kandinski who had said that 'when, in a picture, a line is freed of the necessity to represent a thing the line itself becomes a thing, and its inner harmonies, no longer weakened by secondary aspects, show themselves in all their own interior force' (*Cinquant'Anni a Dada*, p. 17).

A similar logic characterized their attitude towards conventional music – the Dadaists preferring the 'noise music' of the futurists. Their suspicion of music sprang from its apparently ordered form, its harmony. *Bruitisme*, on the other hand, reflected their belief in flux, disorder, and contradiction. Marinetti, in his futurist experiments, had gathered together drums, rattles and typewriters to create an audible impression of the modern environment. The Dadaists now followed his lead, creating at times bewildering cacophonies which worked both to provoke an exasperated public and to convey by means of sound a sense of the multiplicity of simultaneous experience which was the essence of life.

Given their distrust of art and literature, together with their suspicion of language and their belief in the disordered nature of existence, one might logically question the point of the Dadaists' creating at all. This, indeed, has always been a paradox of art, for the creative act presumably implies the existence of order and the possibility and desirability of communication. The fact that the Dadaists were aware of this dilemma and themselves questioned the consistency of their actions explains the elevated position occupied by Vaché, Duchamp, Cravan and, in retrospect,

Rimbaud – all of whom had chosen silence for one reason or another. But consistency was not a quality always admired by a group for whom reason and logic are fundamentally stultifying.

Dada wanted not to endorse the supposedly rational system which, after all, had moved with logical precision towards the brutality of war, but to reconcile man with his freedom and to an extent with the natural world. It thus launched an assault on the enemy of that freedom and sought to divest man of those elements which distinguished him from that natural world – namely reason and egotism. It was a reaction against a mechanistic interpretation of the world which had placed man firmly in control of the universe only on condition that he submit to the mechanics of order, evolution and scientific certainty.

The assault on reason was of course scarcely a new phenomenon. Henri Bergson had attacked the French assumption that logic and lucidity were the twin foundations of human activity, declaring intellect to be the enemy of the new and the vital: 'Precisely because it is always trying to reconstitute, and to reconstitute with what is given, the intellect lets what is *new* in each moment of a history escape. It does not admit the unforeseeable. It rejects all creation. . . . The intellect can no more admit complete novelty than real becoming . . . the intellect, so skilful in dealing with the inert, is awkward the moment it touches the living . . . *The intellect is characterized by a natural inability to comprehend life.*' In the place of reason he advanced the power of intuitive perception 'moulded on the very form of life'. Intelligence, he insisted, 'treats everything mechanically' but instinct 'proceeds, so to speak, organically' (*Creative Evolution*, pp. 172–4). In a similar spirit Gide was later to ask, 'who will deliver our minds from the heavy chains of logic?' (Raymond, p. 253). Like Gide the Dadaists felt that the gratuitous act was a means of breaking the stranglehold of the moral and social system. It was not simply a surrendering of artistic control but an assertion of individual and artistic freedom.

The provocative element in Dada – its desire to shock and outrage bourgeois sentiment – gave it a public image which has to an extent been enshrined in subsequent criticism. Even as perceptive a critic as Marcel Raymond concedes its 'total negation', quoting as evidence several ambiguous assertions by Tzara, Breton and Ribemont-Dessaignes. Tzara is quoted as saying, 'measured by the scale of eternity, any activity is futile'; André Breton, 'it is inadmissible that man should leave a trace of his passage on earth'. These assertions, together with Ribemont-Dessaigne's admission of the enigmatic nature of reality, 'what is beautiful? What is ugly? What is great, strong, weak? What is Carpentier, Renan, Foch? Don't know. What is myself? Don't know. Don't know, don't know, don't know,' (Raymond, p. 246) finally convince Raymond of the movement's futility. Yet these statements do not add up either to pessimism, or to total negation. They assert the significance of the ephemeral and freedom from arbitrary criteria. And although it is not difficult to discover many assertions of the negative function of Data, especially from the Dadists themselves, the force of their work underlines the positive qualities of a group which challenged the cultural and social assumptions of its day, not merely in a spirit of disgusted reaction but in a genuine attempt to rediscover the real function of the artist in an age of violent dissolution.

Its predilection for scatological language and apparently childish antics established it with the general public as at best a symptom of the age and at worst a destructive and juvenile practical joke. Raised to admire mimetic art and to praise genuine craftsmanship they were suspicious of those who, contemptuous of both, chose instead to penetrate areas remote from immediate and literal experience. Given the inherent conservatism of the bourgeoisie the shock tactics of the Dadaists are readily understandable. But the Dadaists did not regard provocation as an end in itself. It was a means whereby they hoped, somewhat forlornly, to shock people

out of a torpid acquiescence in outmoded values. It was a public demonstration of the fact that art should not be regarded as an anodyne. The Dadaists wanted to create a new sensitivity, a vital awareness hitherto blunted by meaningless routine, sterile cerebration, and what they took to be the servile realism or self-serving arrogance of art. Thus when Tzara read a newspaper while Paul Éluard and a friend rang bells as loudly as they could, blotting out the sound of his voice, this was not to be regarded as simply an anti-art gesture, although it was that, nor as a provocation, although it was that as well; it was a lesson in Dada aesthetics, and a restoration of the human element. As Tzara himself explained, 'all that I wanted to convey was simply that my presence on the stage, the sight of my face and my movements, ought to satisfy people's cusiority and that anything I might have said really had no importance' (Wilson, p. 304).

Far from desiring to create an esoteric or privatist art, unavailable to those around them, the Dadaists were proselytizers for freedom and originality. If the message they sought to communicate seemed alternately obscure and simplistic, this, they maintained, was because people too readily confused profundity with solemnity. With a programme whose declared intention, as Hugo Ball modestly put it, was to 'contradict existing world orders' (Motherwell, p. 51) solipsism was clearly self-defeating. Thus, while sharing the symbolists' disgust with society as then structured, Dada never embraced their concern with methodology nor, appearances notwithstanding, their subjectivism. Dada was nothing if not pragmatic, eclectic and self-advertising. It used whatever methods and styles were likely to accomplish its ends and, while protecting itself from facile criticism with a degree of deliberate mystification, shouted its basic message to the world, showing a skill for public relations which has scarcely been surpassed in the arts.

Nevertheless, it is undoubtedly true that sheer exuberance

frequently overcame serious purpose. Facility is sometimes the price one pays for spontaneity, and admiration for the arbitrary is as likely to lead to pretentious posturing as to vital innovation. The Dadaists were by no means united in their aims nor were they able to recognize the full implications of their activities. The heady excitement of the Cabaret Voltaire and its successors obviously offered its own rewards while the coterie which grew up tended to generate its own exclusiveness, as evidenced by the sectional fighting which characterized the dying phases of Dada. The perversity of Dada – 'Peace at any price is the slogan of DADA in time of war, while in time of peace the slogan of DADA is: War at any price' – constantly threatens to degenerate into an obstinate wilfulness prefiguring the self-conscious mannerism of camp art.

The Dadaists were fully aware that anti-dogmatism can become dogmatic and that anti-art can be seen as a form of art and were fascinated by the paradox. While insisting that all writers should be free to express their own concerns they delighted in denouncing all those who 'abused' their freedom. Since this list included most known artists Dada was not without its tinge of megalomania.

In truth Dada was not really even anti-art. Considering the number of artists who flocked to its banner it would have been surprising if it had been. Its enemy was the abuse of art – the use to which it had been put by generations who seemed, to the Dadaists, to disregard the ability of art to capture the truth of life. Like all literary and artistic movements its aim was to penetrate to some transcendent truth visible only to the individual with the intuitive perception to touch the core of existence. Dada, then, was against what man had made of art – a nerveless, deluded, super-ficial image of an ordered existence.

In a strict sense there was little 'original' about Dada. While constantly stressing the derivative nature of literature and art the Dadaists themselves employed techniques and pursued aims for-mulated by others. In particular, the futurists had anticipated

virtually the whole repertoire of Dada experiments, from *bruitisme* and the simultaneous poem through to the use of the manifesto and the provocative performance. But futurism lacked the liberal soul of Dada. Its exponents were intense nationalists who greeted the war with enthusiasm, volunteering for the armed forces as many of the Dadaists quietly made themselves scarce. They enthused not only over the war itself but over the technical apparatus which was so convincingly proving its superiority over vulnerable mankind. Their pictures were filled with tanks and guns, broken down into a series of facets and planes expressing their power and dynamism. The Dadaists on the other hand were internationalists who, the above quotation notwithstanding, opposed the war and shunned infatuation with the mechanical. When they employed machines it was with a sense of irony and humour which gave their movement a human dimension lacking in futurism. If they shared the futurist's desire to 'burn the museums' and 'kill the moonlight' they had no wish to burn the custodians along with the masterpieces or to kill Turks along with the moonlight. The futurists preached man's glorious subjugation to the machine and to process; the Dadaists announced his freedom and thumbed their noses at authority in all areas of life, doing so in the name of man rather than the dynamo. The significance of Dada does not lie in the methods which it devised or adopted, nor in its role as progenitor of surrealism, but in its assertion of artistic freedom and its radical questioning of values and forms. Negative, in that it rejected the achievements of the past, positive, in that it stressed the need for a creative scepticism, Dada contained the contradictions of a generation born into an age of artistic revolution and coming to maturity in time of war. Believing that creation is action they dramatized their sense of rebellion, in so doing achieving a public impact usually denied the artist.

Part Two/Surrealism

4
Definitions, Statements and Manifestoes

I believe in the future resolution of these two states – outwardly so contradictory – which are dream and reality, into a sort of absolute reality, a *surreality*.

(Manifeste du Surréalisme, 1924)

SURREALISM, noun, masc., Pure psychic automatism by which it is intended to express, either verbally or in writing, the true function of thought. Thought dictated in the absence of all control exerted by reason, and outside all aesthetic or moral control.

(Manifeste du Surréalisme, 1924)

(1) We have nothing to do with literature. But we are quite capable, if need be, of making use of it like everyone else.
(2) Surrealism is not a new means of expression, nor a simpler one, nor even a metaphysic of poetry. It is a means of total liberation of the mind and of everything resembling it.
(3) We are determined to create a Revolution.
(4) We have bracketed the word Surrealism with the word Revolution solely to show the disinterested, detached and even quite desperate character of the revolution.
(5) We lay no claim to changing anything in men's errors but we intend to show them the fragility of their thoughts, and on what shaking foundations, what hollow ground they have built their shaking houses.
(6) We hurl this formal warning into the face of society; whatever protection it affords its disparities, each of the false moves of its spirit, we shall never miss our aim. . .
(7) We are specialists in Revolt. There is no means of action we are not capable of using if the need arises . . .

Surrealism is not a poetic form.
It is a cry of the mind turning toward itself and determined in desperation to crush its fetters.
And, if need be, by material hammers.

(Déclaration du 27 janvier 1925)

The acknowledgement of dialectical materialism as the sole revolutionary philosophy, the comprehension and unreserved acceptance of this materialism by intellectuals of idealistic tendencies, no matter how consistent such idealism may be, with regard to the concrete problems of the Revolution – these are the essential features of the development of the surrealists.

(Le Surréalisme au service de la révolution, No. 3)

Automatism, inherited from the mediums, remains one of the two major trends of surrealism.

(Le Surréalisme et la peinture, 1927, André Breton)

Everything tends to make us believe that there exists a certain point of the mind at which life and death, the real and the imagined, past and future, the communicable and the incommunicable, high and low, cease to be perceived as contradictions. Now, search as one may one will never find any other motivating force in the activities of the Surrealists than the hope of finding and fixing this point. From this it becomes obvious how absurd it would be to define Surrealism solely as constructive or destructive: the point to which we are referring is *a fortiori* that point where construction and destruction can no longer be brandished one against the other.

(Le Second Manifeste du Surréalisme, 1929)

The well-known lack of frontiers between *non-madness* and madness does not induce me to accord a different value to the perceptions and ideas which are the result of one or the other.

(Nadja, André Breton)

Beauty will be CONVULSIVE or will not be at all.

(Nadja, André Breton)

5
Birth, Progress and Politics

One evening in 1919 André Breton was struck by a phrase which 'knocked at the window' of his consciousness. Though the sharpness of the image faded, he recalled the words, 'there is a man cut in two by the window'. This somewhat bizarre revelation was accompanied by a visual image and immediately followed by a number of equally gratuitous phrases which came into his mind without conscious volition. Familiar with the techniques of Freudian analysis Breton then attempted to give free rein to this arbitrary flow of images, unmediated by rational control. The written accounts of such experiences, the 'automatic texts', which followed were instantly accepted by the Dadaists but they were in fact the first stirrings of a more determinedly experimental movement – surrealism.

Surrealism, as defined by Breton, was dedicated to revising our definition of reality. The means which it employed, automatic writing, accounts of dreams, trance narration, poems and paintings created as a result of random influences, art which pictured images of paradox and dream, were all devised to serve the same fundamental purpose – to change our perception of the world and hence to change the world itself. With such a messianic impulse at its heart it is scarcely surprising that it should have quickly enmeshed itself in political evangelism or that it should have been riven with sectarian dissension as its founder and chief prophet struggled to maintain the purity of what he saw as its central goal. But by the same token the sheer scale and effrontery of its objective

guaranteed the enthusiastic commitment of writers and artists who increasingly felt that imagination alone could humanize a decadent art and decaying society.

André Breton was born in Normandy in 1896 which, by one of those coincidences so dear to the surrealists, was also the same year that Alfred Jarry was shocking Parisian audiences with his obscene and satirical fantasy, *Ubu Roi*. Of military age at the outbreak of hostilities he was mobilized first in the artillery and then in the medical corps. The war had a profound impact on him. It created a hatred for bourgeois chauvinism and a contempt for the writer who allowed his talent to be used to express the dangerous platitudes of what C. Wright Mills called the 'power élite'. His work with the wounded and shell-shocked introduced him to the new theories of Freud and brought him into contact with Jacques Vaché, who was to commit suicide in 1919, and Guillaume Apollinaire, whom Vaché derided. From the former, Breton derived an admiration for Jarry and the inspiration to regard himself as a poet; while the latter introduced him to the new literary and artistic movements of his day and later provided the name for the movement which swiftly eclipsed the achievements of Dada.

The word 'surrealism' first made its appearance in Apollinaire's 'absurdist' play, *Les Mamelles de Tirésias*, which was written in 1903 but first performed in 1917. The play was subtitled a 'drame surréaliste'. For Apollinaire the word expressed an analogical way of conveying essential reality. As he pointed out, when man wished to imitate the action of walking he invented the wheel rather than mechanical legs. So, when the artist wishes to convey the fundamental truth of existence, he turns, not to the naturalist's slice of life but to the poet's evocative imagination. When Breton and Soupault looked for a name to describe their experiments it was natural that they should look to Apollinaire. Both men admired his work and in contriving his death to coincide with the celebration of Armistice Day he had assumed a further symbolic

significance as a pivotal figure. (The writers of this time managed their deaths with masterly aplomb – Jacques Rigaut, for example, committing suicide at the age of thirty, having given himself a further decade of life ten years earlier.) In adopting Apollinaire's term, however, Breton imposed his own meaning on it, as he was to transform the meaning of everything he touched, from the headlines which he discovered in a newspaper and incorporated into a poem, to the objects which he found in the market-place and transmuted into mysterious symbols of the marvellous.

According to Hans Richter surrealism 'jumped out of the left ear of Dada fully equipped and alive, making dadaists = surrealists overnight' (Verkauf, p. 68). It is certainly true that men like Breton, Éluard and Aragon, who had constituted an important element of Paris Dada, did become the leaders of this new manifestation of revolt and freedom. Indeed as early as 1919 Breton and Soupault had published the first part of *Les Champs magnétiques* (published in full in 1922), which in retrospect, could be seen as the first truly Surrealist text. But the surrealists preferred to trace their heritage further back than Dada. They found their origin in the gothic novel, in the Marquis de Sade, and in the romantics and symbolists, although, as Breton later confessed, this search for ancestors was not without its irony for writers and artists who claimed to be iconoclasts.

The break with Dada came in 1922, following Breton's abortive conference to determine the course of modernism. If the influence of Dada was not to be so easily dismissed – provocation, for example, continuing to exert a powerful attraction – under the direction of Breton experimentation began to take a new direction. Automatic writing was followed by accounts of dreams and speeches made while under trance, the pursuit of the insights of the subconscious and a reliance on the nonrational which is the essence of surrealism. This was what Breton was later to call the 'intuitive epoch' of Surrealism (and in more sanguine

D

mood, the 'heroic epoch') during which he believed that the mind could free itself of the restrictions of logic, rationality, and conscious control by its own efforts and that thought was 'supreme over matter'. It was this mood which was enshrined in the *Manifeste du Surréalisme*, published in 1924. From the standpoint of his later political commitment this seemed a rather naïve document which, if it accurately reflected the essence of surrealism as it existed at the time, failed to anticipate the radical shift which came in the following year. Nevertheless, the title of the group's first periodical, *La Révolution surréaliste*, which appeared in December 1924, did serve to indicate a commitment to radical change which soon came to embrace the political sphere as eagerly as it had the psychological, leading eventually to a new journal significantly called *Le Surréalisme au service de la révolution*.

In 1925 the new movement flexed its muscles and with a brashness and exuberance reminiscent of the Dadaists sallied forth to do battle with the forces of reaction, determined to assert its commitment to freedom in the face of conservatism. As Breton explained, 'Nous vivons en plein coeur de la société moderne sur un compromis si grave qu'il justifie de notre part toutes les outrances' (Browder, p. 21). They saw themselves as an irritant – but an irritant which was not purely destructive, for they were aware that the pearl is the end-product of an abrasive process, and such pearls, they insisted, were worth the death of a thousand divers. With this in mind they launched an attack on the Chancellors of Europe's universities for breeding men blind to the true mystery of life, on the Pope, for distorting the human spirit, on Anatole France, for his conservatism, and on Paul Claudel, for his effrontery in denouncing them as pederasts.

Like the Dadaists they conducted public skirmishes with reactionary ideas in art and society. They opposed the literary bourgeoisie as they rejected the constrictions of conventional life. Breton ascribed the spiritual conformity and aridity of the middle

class, intellectually to rationalism and logic, morally to the influence of church, state and family, and socially to the apparent necessity of work. The Surrealist thus placed himself in implacable opposition to the whole list – finding himself, somewhat to his surprise, a political as well as a spiritual revolutionary. Where the Dadaists had for the most part dissociated themselves from social and political activity, the surrealists came by degrees to extend their revolutionary activity from the potentially hermetic world of art to the more immediate political arena. Thus it is that the surrealists can be seen as providing a link between Baudelaire, on the barricades of 1848, and the dissident students, on the barricades of 1968; between the enthusiastic commitment of late romanticism and the expansive aims of a group of students who, in the middle of social revolt, could declare, 'Forget all you have learnt, begin dreaming'; 'Down with socialist realism. Long live surrealism.' Surrealism, after all had announced the most revolutionary of policies. Annexing from Marx a commitment to change the world and from Rimbaud a determination to change life, they set themselves the task of altering reality – no less.

To an extent this shift towards political involvement implied a revision of the principles outlined in the First Manifesto. There Breton seemed to allocate an essentially passive role to the writer and artist. They should, he insisted, regard themselves simply as instruments. Continuing the analogy, he had denounced even such writers as Poe, Mallarmé, Jarry, and Reverdy, and such painters as Matisse, Picasso, Picabia, Chirico and Ernst because they 'did not want to serve simply to orchestrate the marvellous score. They were instruments too full of pride, and this is why they have not always produced a harmonious sound.' True surrealists, on the other hand, made 'no effort whatsoever to filter' and regarded themselves as 'simple receptacles of so many echoes, modest recording instruments' (*Manifestoes of Surrealism*, pp. 27–28). But, as the first issue of *La Révolution surréaliste* suggested,

surrealism refused to allow its future to be determined by its past. (Aragon later said that 'I do not admit the right of anyone to re-examine my words, to quote them against me. They are not the terms of a peace treaty' (*Paris Peasant*, p. 215).) Thus the passivity implicit in the early experiments gave way in time to a more avowedly active stance. In 1925, according to Breton, surrealism had already 'ceased to be content with the results (automatic texts, accounts of dreams, improvised speeches, poems, spontaneous drawings or acts) it had initially proposed' (Nadeau, p. 120). Although these methods were by no means abandoned, Breton insisting on their centrality in the Second Manifesto in 1929, they were seen more rigorously for the techniques which they were. The new political awareness, which typified many of the surrealists, meant that experimentation was now seen in a new context.

The events of the Moroccan war of 1925 precipitated an attempt at *rapprochement* between the surrealists and the group associated with the left-wing publication, *Clarté*. This resulted in a joint manifesto, *La Révolution d'abord et toujours*, which was in itself evidence of the radical shift of emphasis on the part of the surrealists. In a sense it marked the end of their initial innocence, for now, by adopting an openly political stance, they were embracing public responsibility of a kind shunned by the Dadaists and regarded by themselves, only a year earlier, as irrelevant or, at best, of secondary importance. This was the start of what Breton, paradoxically, called the 'reasoning epoch'. As he was to assert later, in *What Is Surrealism?* 'today, more than ever before, *the liberation of the mind*, the express aim of surrealism, demands as primary condition, in the opinion of the surrealists, *the liberation of man*, which implies that we must struggle with our fetters with all the energy of despair; that today more than ever before the surrealists entirely rely for the bringing about of the liberation of man upon the proletarian Revolution' (pp. 48–49). The revolution in con-

sciousness, it seemed, was to be a consequence rather than a cause of social change.

The union with *Clarté*, which somewhat incredibly had the blessing of the Soviet Commissar for Education, was by no means total. While pledging themselves to the cause of the working class, Breton and his followers wished to retain complete freedom in their work, a contradiction which was never resolved either at this time or in their subsequent quarrels with the communist party. Not surprisingly *La Guerre civile*, intended to be a joint product of the *Clarté* group and the surrealists, failed to appear, although reportedly mutual respect was somehow sustained. The French Communist Party, on the other hand, was not so sanguine about its putative allies. Certainly *Humanité*, edited now by Henri Barbusse, had little time for a movement which seemed incapable of accepting the full implications of its alleged commitment. But, as Breton argued in a brief pamphlet called *Légitime Défense*, published in 1926, the idea of the surrealists' material and spiritual aims being in opposition made no sense to a group whose central purpose and strategy lay in the reconciliation of such contradictions. *Légitime Défense* was an adroit attempt at simultaneously meeting the nascent objections of the party and the dialectical uncertainty which existed among the surrealists themselves, for if the pamphlet attacked the party it was only to suggest that it was not revolutionary enough. Despite his criticism of the party and in particular of its failure to realize that revolution was not limited to the material world, Breton, together with Éluard, Péret, Unik and Aragon, did join in the following year (1927). But while calling for revolution and endorsing, when possible, the party line, the surrealists seem to have had a somewhat vague idea of the new society for which they were calling and of its value to them as surrealists. Significantly, they saw their role as defending the 'soul' of the party against attacks from outside. When party officials, who were not attuned to the notion of

surrealist defenders of the faith, asked them to co-operate in practical schemes the new converts were aghast. The materialistic emphasis which lay behind this restructuring of society made little sense of their own calls for the release of the imagination. Thus we are faced with the irony that for a brief time the surrealists were virtually the only organized group of intellectuals playing a leading role in the affairs of a French Communist Party which could not begin to understand their philosophy and which they in turn suspected of uncomprehending philistinism. The attraction which the surrealists felt for communism lay in the fact that the party seemed to be the incarnation of revolt. In many ways they were responding to Trotsky's association of communism with the idea of an optimistic freedom – social and metaphysical. Entranced by this image they were, for a while, blind to the growing determinism of a movement which eventually came to see Trotsky as an enemy and intellectual freedom as a threat to the construction of socialist unity. Their flirtation should be seen as an endorsement of iconoclasm; their eventual renunciation as a rejection of determinism. The decision to join the party, therefore, was a gesture which indicated the extent of their commitment but which did nothing to conceal the contradictions which led eventually to the inevitable break.

Breton's failure to anticipate the intolerable pressures which were soon brought to bear on him is the more surprising when placed beside the position outlined in *Légitime Défense*. None the less for a time at least, he seems to have been genuinely convinced by the party sophistry which sought to present disagreement as radical disaffection and neutrality as opposition. Perhaps one explanation for his acceptance of party diktats lies in the corresponding fervour with which he insisted on protecting the purity of surrealist orthodoxy. With an almost religious zeal he excommunicated all those who seemed to deviate from the true faith and who failed to show his own dialectical dexterity. Thus

Artaud, Desnos, and Ribemont-Dessaignes were invited to leave because they did not follow Breton in pledging allegiance to the party, wanting instead to 'maintain surrealism on a purely speculative level'. At the same time he defended himself against what he regarded as heresy on the left wing, by dismissing Aragon and Naville for their 'ill-conceived political militancy' (*What Is Surrealism?*, p. 68).

Despite the arguments and denunciations which dominated this 'reasoning epoch' these years were incredibly productive. Aragon had published *Traité du style* and *Le Paysan de Paris*, Éluard, *L'Amour la poésie*, Breton, the surrealist novel *Nadja* (itself a contradictory gesture since he had attacked the novel form in his manifesto) and Naville, *La Révolution et les Intellectuels*. Surrealism also conquered new areas: Luis Buñuel's film, *Un Chien andalou* demonstrated the cinema's unique ability to stimulate the subconscious; the establishment of the Galerie Surréaliste in 1926 underlined the growing importance of surrealist art – a phenomenon which, in skirting problems of translation and conveying directly the visual element only obliquely reconstructed in the written text, proved far more suitable for export and, arguably, more effective in expressing the paradoxical images of the subconscious.

Buñuel's *Un Chien andalou* was a product of what he himself called 'a conscious psychic automatism'. Its paradoxical images, its verbal and visual puns together with the flexibility of a form which could create visual effects of a kind impossible for the writer or painter, explain the significance which the cinema came to assume for the surrealists. Because of the forbidding expense of film-making many surrealist projects came to nothing, scenarios by Artaud, Desnos and Brunius never getting beyond the printed page. But the work of Buñuel and Dali, and later of Wilhelm Freddie and Harold Muller, demonstrated the potential of the medium.

Buñuel's films, which exhibit a more clearly symbolic dimension than most surrealist material, have always been provocative. In *Un Chien andalou* a woman's eye is sliced in two by a razor blade while in *L'Age d'Or* de Sade's Duke of Blangis emerges from the Castle of Selliny, after one hundred and twenty days of orgies, in the guise of Jesus Christ – a gesture which, at the film's first showing, understandably provoked a violent response from a largely Catholic audience.

Man in these films is portrayed as distorted and burdened by a society which distrusts passion and despises spontaneity, but Buñuel's caustic humour deflates the pomposity of those characters who choose to place convention before humanity. At the same time the anarchic freedom of Buñuel's technique stands as a strikingly effective example of a surrealist liberty whose dynamic force seems more perfectly expressed through the fluidity of a visual medium than through the necessarily static force of the written text.

Surrealism was at first the creation of writers. Indeed the possibility of surrealist art was called into question in the early editions of *La Révolution surréaliste*. Certainly, of the twenty-six signatories of the January Declaration in 1925, only three were painters. Yet, as if to refute this, the first exhibition of surrealist art was actually held in that same year. It was admittedly an eclectic affair which drew on the work of painters like Arp, Klee and Picasso as well as Man Ray, Miró and Max Ernst. Chirico's work, which was also shown, was an obvious precursor of surrealism but, as Sarone Alexandrian has pointed out, the paintings which he produced during the mid-twenties were, for the most part, so far from being surrealist that when he mounted an exhibition in 1928 the surrealists set up a rival one at which they displayed his earlier work. Breton himself seemed confident of the possibility of surrealist art – an art which must concern itself with enlarging the scope of reality. He found partial evidence of such work in Chirico,

Duchamp, Ray and Klee, but it was in the experiments of Max Ernst, and, more especially, in his collages, that he saw the surreal at work. The very technique of the collage, the deliberate juxtaposition of objects, the dissonance between object and context, was surrealist.

In 1925 Ernst discovered a process which he equated with automatic writing. Using a method similar to that which produces brass rubbings he secured a tracing of the texture of wooden floorboards. This in turn, rather like a Rorschach ink-blot test, suggested certain forms to him. He called the process *frottage* and, perhaps somewhat spuriously, saw the artist as displaying the passivity associated with automatic writing. In reality it is arguable that a great deal of conscious choice was required, from the selection of object, to the size and colour of the frottage itself. None the less Ernst's frottages, the first of which were published in 1926, effectively mark the birth of surrealism in art – an occasion celebrated by the establishment in the same year of a Surrealist Gallery which became the scene of a number of subsequent exhibitions of surrealist art.

The series of articles which Breton published in *La Révolution surréaliste* under the title, 'La Surréalisme et la Peinture' and which was concluded in 1927, does not, however, reveal the coherence which typified the literary aspect of surrealism. As critics have pointed out the title itself seems to accept a distinction between surrealism and painting which reveals a fundamental lack of conviction on Breton's part. Thus, in spite of his own assertions to the contrary, there would at this moment still seem to be some doubt in his mind if not that surrealist painting was possible at least that it was possible to define its characteristics and achievements.

By 1929 Breton felt the need for a re-examination of the aims and objectives of a movement which in a decade had adopted a number of seemingly contradictory poses and which had suffered both defections and expulsions (the list now included Queneau,

Miró and Vitrac among many others) as well as the infusion of new blood (Buñuel and Dali). Accordingly he invited replies to a letter which he sent to all those associated with the movement. The ensuing discussion proved predictably abortive from one point of view but succeeded in sorting out the surrealist sheep from the politically unreliable and aesthetically self-conscious goats. Breton then outlined his own position in the *Le Second Manifeste du Surréalisme*, which affirmed the central commitment to revolt and to an expanded sense of reality but which criticized early errors which had led to an assertion of historical justification and a confusion between method and purpose. The manifesto rejected the bad faith of those who had been guilty of various heresies (he indicted Artaud, Masson and Soupault among many others) and constituted a justification of his twin faiths – dialectical materialism and surrealism. It was apparently a plea to the party not to look on the surrealists as 'strange animals', whimsical and defiant, but rather as allies operating in a field outside the province of the working-class revolution. But from the tone of despair with which he mentions the French Communist Party it is clear that the manifesto is more justification than supplication.

As time went by, indeed, it became increasingly difficult for either the French Party or the surrealists to regard each other with anything less than considerable suspicion. The communist attitude towards culture became more severe while political opportunism left many of its supporters in a moral dilemma. The surrealists, on the other hand, were largely of bourgeois origins and evidenced what, from a Marxist viewpoint, seemed élitist attitudes. Certainly their work had little to say to the proletariat and, judging by the automatic texts and dream narrations published during the twenties, little of any political worth to say at all. There was, too, a suspicion that involvement with the party was conferring a significance on the surrealists and granting them revolutionary

credentials which they might otherwise have lacked. At any rate the alliance, such as it was, did not survive much longer.

In 1932 Aragon, together with a small group which included Pierre Unik and Luis Buñuel, not merely joined the party but made it clear that it, and not surrealism, now had their primary loyalty. Although the surrealists staunchly defended Aragon when he was charged with sedition for his polemical poem 'Red Front', they did so in terms which were unacceptable either to Aragon or the party. Thus Aragon publicly broke with the surrealists, even denouncing them as counter-revolutionary – an ironical appellation for a group which regarded communism as merely a minimum programme.

Two years later the Soviet pronouncement of the dogma of socialist realism confronted the surrealists with the very spectre which they had denounced in the First Manifesto. But whatever their doubts the issue had already been resolved when in 1933, following an attack on puritanism in the new Russia, by Ferdinand Alquié, the surrealists, with two exceptions, were all expelled.

Despite this and despite the reversal of policies which brought about an alliance between the communists and the French socialists which left the communists supporting precisely that militarism which the surrealists had rejected by joining the party in 1927, the final break on the surrealist side did not come about until 1935. After Breton had been refused permission to speak at the International Congress for the Defence of Culture they issued a pamphlet, *Du temps que les surréalistes avaient raison*, denouncing the Soviet regime in general and Stalin in particular. The document ended with the surrealists shaking a metaphorical fist in the face of a movement which they had once seen as playing a leading role in the liberation of mankind.

But in rejecting the party the surrealists were not abandoning their commitment to revolt. Indeed their central accusation of the party was that it had betrayed its own revolutionary integrity. In

La Position politique du Surréalisme, published in that same year, Breton attempted a more detailed denunciation of the party's inadequacy and announced the founding of a new publication, *Contre-Attaque*, which was to be the organ of those revolutionaries who found it impossible to comply with the expedient and largely philistine dictates of party orthodoxy. Breton found Marx's call for 'more consciousness' finally irreconcilable with the petty dogmatism of party functionaries. Real advance for the surrealists lay, it seems, less in the arid and compromised assertions of the left than in the vivid experiments of the increasingly right-wing Salvador Dali. He had already established his credentials with his formulation of *paranoia-criticism*, the principle of subversion which underlies most of his paintings. But the most important advance for the surrealists in the mid-thirties was the primary importance accorded to the *surrealist object*, which was a natural outgrowth of the work of Dali and Magritte and which marked a return to the experimental mood of the early twenties. These 'objects perceived only dreams' were selected for their evocative quality. In a sense they were extensions of Duchamp's ready-mades but their central purpose was to subvert the utilitarian – to disconcert the literal-minded observer, to disturb his sense of reality and grant him a glimpse of the 'marvellous'. Thus in the 1936 exhibition of surrealist objects, held in Paris, Meret Oppenheim exhibited a 'Fur-Covered Cup, Saucer, and Spoon', while Dali, in the same year, created, 'The Venus de Milo of the Drawers' – the famous statue adapted as a 'chest' of drawers. Both mocked the merely functional, the one in daily life, the other in art.

The war took most of the surrealists to the United States, including Breton, Ernst, Tanguy and Dali, although the latter's fascist leanings and commercial instinct had long since alienated him from Breton. They were well received in their exile, contribut-

ing to such magazines as *VVV* and participating in an exhibition organized in New York in 1942, before returning to Europe at the end of hostilities. The expatriate years had a two-fold effect. On the one hand the surrealists left behind in America an inheritance not merely of American surrealists, such as Robert Motherwell, or those drawing on surrealist method, such as Mark Rothko and Ashile Gorky, but most significantly a lingering influence on the work of Jackson Pollock and the abstract expressionists. As Pollock himself explained, 'I accept the fact that the important painting of the last hundred years was done in France. American painters have generally missed the point of modern painting from beginning to end. . . . Thus the fact that good European moderns are now here is very important, for they bring with them an understanding of the problems of modern painting. I am particularly impressed with their concept of the source of art being the Unconscious.' Though he went on to admit that 'the idea interests me more than these specific painters do, for the two artists I admire most, Picasso and Miró, are still abroad' (Geldzahler, p. 183) the influence was an important one. The other important effect of the expatriate years lay in the fact that it tended to create a gulf between the surrealists and France. Although Éluard, who stayed behind in his native country, had fought with the Resistance, and Breton had at least broadcast for the Voice of America, their failure to contribute directly to the war effort may to some extent account for their failure to re-establish their influence and importance on their return to France. It was Camus and Sartre, the latter directly opposed to the surrealists in many ways, who between them determined the nature of the post-war dialectic in France – a dialectic which allowed little room for the surrealists. They continued to work and to stage exhibitions (the International Exhibition of 1947 had contributors from twenty-seven countries) but these increasingly had the air of retrospectives which were not entirely divorced from a kind of nostalgia which

had little place in the surrealist canon. They did continue to strike public poses on the war in Algeria and on Gaullism, but although their influence was still apparent in poetry and art surrealism seemed to have aspired to the very status against which it had fought with such determination. It was increasingly regarded as a movement which could be conveniently contained by the two wars. In many ways the surrealists under-estimated the ability of society to absorb the subversive image and sustain the impact of anarchic imagination. As Dali demonstrated, the marvellous proved a thoroughly marketable commodity. It was not for nothing that Breton renamed him Avida Dollars. Over the years surrealism has acquired a potentially embarrassing respectability and, more disturbingly, assumed a definite position in the rational catalogue of twentieth-century art and letters.

Yet surrealism did not die with VE day. Not only had the germ been spread to the United States, to Latin America and the Caribbean, and a dozen European countries, but the insight which it offered and the method which it outlined has continued to be relevant. It was therefore hardly surprising that the events of 1968 in France should have been accompanied by surrealist slogans or that the logical application of military technology in Vietnam should have been accompanied by a renewal of the surrealist spirit in the United States.

England remained curiously unaffected by all this (see Paul C. Ray, *The Surrealist Movement in England*). Partly because of a natural insularity, reinforced by a traditional and unashamed ignorance of foreign languages and suspicion of foreign ideas, the exuberant early years of a movement which rapidly spread throughout the world left English writers and artists largely unmoved. Despite a native tradition which included the fantastic absurdities of Lewis's *The Monk*, or, in another mood, the creations of Lewis Carroll and Edward Lear, as well as the visionary creations of Blake, there was little enthusiasm for a group which

purported to despise literature and bourgeois society alike. The freedom of the surrealist poets seemed less radical from the perspective of English romanticism and modernism, while the anticlericism, which so shocked the French public, failed to provoke much more than wry amusement in a society so lacking in Catholic fervour and so inherently distrustful of passion.

The English learnt about surrealism not from Breton's manifesto and the bitter disputes of the early years but from David Gascoyne's *A Short Survey of Surrealism*, published in 1935, or from the International Surrealist Exhibition staged in London in 1936. In other words surrealism was more than a decade in reaching England and arrived when much of its vital force had been spent. The 1936 Exhibition did serve, however, to bring the Belgian painter E. L. T. Mesens to Britain where he established the London Gallery and published the *London Gallery Bulletin* which, during the four years of its existence, was perhaps the single most important means of propagating surrealism in England.

While there remains even today a vestigial surrealist group, with its own magazine, its energy is somewhat attenuated and it remains a minor and insignificant influence. Without the dominant personality of an André Breton to keep the blood coursing English surrealism was virtually still-born and if its heart did succeed in beating, however feebly, it did not prove capable of propagating itself when the time came.

6
Origins, Aesthetics
and Ethics

Dada had arguably played a vital role in releasing the artist from the past. It had introduced a caesura into the continuity of art; it had challenged orthodoxy in taste, in social habit and in moral assumptions; it had questioned conventional wisdom and defied inflexible criticism. But it had not completely liberated the imagination or developed a coherent aesthetic of its own. If it prophesied the existence of other gods, it was not itself those gods. As André Breton realized, '*Le Manifeste Dada 1918* semblait ouvrir toutes grandes les portes, mais on découvre que ces portes donnent sur un corridor qui tourne en rond' (*An Anthology of French Surrealist Poetry*, p. 10). The surrealists offered a way out of this impasse by setting themselves a number of tasks. They sought to restore imagination to its central role (also, in Stephen Spender's view, an essential tenet of modernism), to redeem language, to investigate the potential of the unconscious and to seek that mystical point at which contradiction resolves itself into synthesis. It was a programme, as Breton recognized, which linked them with earlier writers, and in particular with the romantics and the symbolists: Nerval, Baudelaire, Mallarmé, Lautréamont, Rimbaud, and Apollinaire.

In identifying their predecessors the surrealists were highly selective. Thus one suspects that they admired the socialist Fourier for his faith in the unrestrained indulgence of human passions and for his suspicion of commercialism and the repressive State, but not for his indecent fervour for industry and hard work.

So, too, they were attracted by Hegel's commitment to freedom and his concern with the reconciliation of opposites; his obsession with formalized structures and power politics can have held little attraction. Theirs, in other words, was a kind of eclectic alchemy. They isolated the active ingredients of their chosen ancestors and claimed them as elements in their own verbal necromancy. They were fascinated with Nerval because of the work which he produced while in a state of mental instability (themselves deliberately simulating states of madness in pursuit of the unique insights which they associated with insanity) but disregarded the terrifying force of that madness which led, in 1855, to his suicide by hanging. They admired Mallarmé the rebel, the man alive to the incandescent quality of words, who looked for an 'orphic explanation of the earth', but ignored Mallarmé the decadent. They embraced the Baudelaire who combined public commitment with a fascination for the inner world but showed little inclination to absorb the lyrical assertions of his romanticism. Nevertheless, the links with romanticism and symbolism do serve to underline the nature of their own concerns and their significance in relation to that tradition of French art and literature which in other ways they saw themselves as opposing.

The Romantics in England could regard themselves as part of a tradition which went back to the sixteenth and seventeenth centuries. This was not true in France. Here the classical tradition had dominated, and the Romantic Movement, with a few individual exceptions, lacked the force to fulfil its iconoclastic potential. It was a temporary deviation from what seemed to be a classical norm. The intensely subjective, individualistic world of romanticism, in which man was in alliance with nature, was a reaction against the objective, public world of classicism in which man dominated nature. But, inevitably, in accord with a kind of literary Newton's law, it, in turn, provoked a further reaction. In the mid-nineteenth century the naturalists, with clinical disinterest,

were describing man as a victim of nature while a group of neo-classicists who, significantly, called themselves the Parnassiens and who included among their number Gautier and Leconte de Lisle, demonstrated the precision of craftsmen and the accuracy of historians in perfectly structured verse. The extravagances of romanticism were, it seemed, to be disciplined by the reassertion of the essential French tradition. But the seeds of the movement which was to rival the Parnassiens had already been sown by the romantics themselves: by Nerval and Baudlaire or, in America, by Poe. Symbolism, which emerged in the closing decades of the century, was a plunge back to subjectivity, to an investigation of the self, to a faith in the possibility of synthesis which was an extension of the faith voiced by Baudelaire, Coleridge and Wagner. The symbolists concerned themselves with the indefinite rather than the precise and in doing so fractured the flawless metrical structure which had characterized the romantic and classical form alike in France. They were more interested in sensibility than sense and reached out, at least in theory, to the other arts, seeing invisible lines connecting music, art and poetry. It was Apollinaire who, in a programme note for Stravinsky's ballet, *Parade*, saw the alliance manifested there as a kind of 'surrealism'. In 1897 Yeats could say that the reaction against the rationalism of the eighteenth century had mingled with a reaction against the materialism of the nineteenth century to create in the symbolists the only genuine originality then observable in the arts.

It is hardly surprising, therefore, that the surrealists should identify themselves with writers who had dedicated themselves to undermining the oppressive dignity of French classicism and the cloying determinism of naturalism or that they should stress their kinship with writers dedicated to experiments so like their own. Like the romantics (Hoffmann, Novalis, Coleridge, Nerval, Baudelaire) who had concerned themselves with dreams, hypnosis,

somnambulism, madness and hallucinations, they were fascinated by the unconscious. Like Novalis, for whom thinking was merely a pale reflection of feeling, they believed in the integrity and significance of emotional response, and like the German romantics, like Baudelaire, or, in England, Coleridge, they were concerned with the possibility of some final synthesis which lay behind the appearance of heterogeneity and even contradiction. But, above all, the surrealists join with the romantics in their justification of the imagination in the face of rationalism and materialism. Perhaps this in part accounts for the admiration which André Breton expressed for the gothic novel, itself an expression of the romantic spirit. The gothic romance implied that the world is dominated by forces not acknowledged by the rational mind. It broke free of the novel of manners and didactic sensibility to take account of areas of experience hitherto disregarded. Too often, however, it betrayed its own assertions and concluded by capitulating to rationalism, denying the very force which gave it its energy and compulsive mystery. The surrealists had a steadier nerve.

The connection between surrealism and romanticism is a close one but the distinctions are equally real and revealing. While Breton conceded the relationship he wisely insisted that surrealism was only the 'prehensile tail' of romanticism. The romantic tended to see the imagination as opening up a path to the great abstractions; to God, Beauty, Truth. The surrealist saw it as liberating man from such abstractions as it freed him from a restrictive logic. For the surrealists poetry itself was not a formal structure. It was a quality which existed in isolation from the manner in which it found expression. Indeed, since it was an 'activity of the mind' one could be a poet without writing poetry. The surrealists did not see themselves as an *avant-garde* movement in literature or painting but as revolutionaries intent on changing the nature of consciousness and altering our conception of the nature of reality. If they believed that entry to the surreal lay through the

self they did not believe that the sensibility of the artist had the significance granted to it by the romantics. For romantic egotism they substituted a self which absorbs experience without asserting a self-consciously heroic individuality. The insights of Darwin, Marx and Freud had underlined the declining autonomy of the self. What the surrealists counterposed to this was not a vision of an anthropomorphic universe but a desperate assertion of the need to rediscover the significance of the non-material world. While the romantics turned to visible nature both for evidence of spiritual forces and for analogues of their own state of mind, the surrealists deliberately closed their eyes to a reality so empty of imaginative insight. The famous photograph of the surrealists with their eyes shut is only partly a joke; it is also an accurate reflection of their stance and of the internal nature of their quest.

The surrealist method, as we have seen, lay partly in the ascription of uncommon properties to common objects, the confrontation of apparently unrelated objects, ideas, or words, and the wilful dislocation of object and context. This sounds, of course, a familiar enough process. It is, after all, the basis of the poetic image. Johnson defined the metaphysical conceit as 'the most heterogeneous ideas ... yoked by violence together'. But the conceit depends for its effect precisely upon a demonstrable and logical connection between ideas which only *seem* to be heterogeneous. Where there appears to be contradiction there is perfect symmetry. The same is also true, to a certain extent, of the German romantics or of Coleridge, though here the connection is largely emotional or sensual rather than intellectual. This applies, of course, equally well to Baudelaire, who identified the correspondences or analogies between senses or objects and who expressed this intangible connection through the metaphor. The romantic image thus mediates between inspired perception and the need to communicate this intuitive truth. It is a compromise – a means of expressing the inexpressible. But for the surrealist the image is not an expres-

sion of the ineffable; it creates the ineffable. The surrealist writer is not inspired; he is an inspirer. The image does not represent a state of mind or a heightened sensibility; it forges that state of mind and provokes that sensibility. It is a springboard to freedom which is simultaneously both means and end. The confrontation of disparate ideas and words serves to break the analogical mode of the mind and liberate the imagination. The surrealist, then, is not interested in the nature of the flints; his concern is with the spark. As Reverdy had said in 1918, 'the image is a pure creation of the spirit. It cannot be born of a comparison but of the bringing together of two realities which are more or less remote. The more distant and just the relationship of these two conjoined realities, the stronger the image – the more emotive power and poetic reality it will have' (Waldberg, p. 22).

Yet there is arguably a contradiction between the surrealists' desire for moral commitment and a style and purpose which, as Sartre has pointed out, suggests detachment. It is hard, for example, to reconcile a suspicion of objective reality, such as that expressed by Breton, Aragon and Dali, with a commitment to dialectical materialism, which by definition is predicated on the concrete necessities of a material world. It is equally arguable that the violent, bizarre and essentially ambiguous and personal image itself implies a certain moral detachment and ethical neutrality. It is not the weapon of the committed man; he turns to simple metaphor and to allegory. Thus it should have been clear from the very beginning that the communist party would hardly be likely to endorse the ambivalence, the anarchic freedom of imagination, which characterized Breton and his followers and which was the basis of their methodology. It should have been equally clear to the surrealists that theirs was a method simply not capable of serving a political cause. The surrealist approach necessarily confounds the notion that everything is knowable. Here symbolism and surrealism touch but surrealism and communism diverge.

While communism is rooted in the possibility of rational analysis, both of the other groups would join with Thoreau in saying, 'Give me a sentence which no intelligence can understand. There must be a kind of life and palpitation to it, and under its words a kind of blood must circulate for ever' (Matthiessen, p. 85).

It should be obvious from this that surrealism confronts the unwary literary critic with genuine difficulties, and this not merely because of the sybilline impenetrability of many surrealist texts or because of its consistent disregard for the formal canons of literature and art. Indeed, to indict surrealist poetry for its obscurity is to misunderstand the whole nature of surrealism for, as Breton pointed out, lucidity, to his mind, was 'the great enemy of revelation' for it is 'only when the latter has come about that the former can be authorized to command respect for its rights' (Matthews, p. 206). The real critical dilemma arises from the avowedly anti-literary stance of the surrealists. For surrealism, which showed a consistent contempt for 'literature', was not concerned with refining literary techniques or forging new forms of art, but with tapping the resources of the subconscious and liberating the captive spirit. The striking image was not, as it was for the romantics and the symbolists, a conscious literary gesture, a means of conveying a fixed meaning or mood. It, and the bewildering flow of automatic writing in which it occurred, was an attempt to by-pass what the surrealists saw as the conventional timidity of art and the restrictive raionality of bourgeois society.

They were intent on turning to their own purpose even the forms which had been devised by their predecessors. Though Breton affected to despise the novel this too proved susceptible to surrealist subversion, as Breton himself proved with *Nadja* and Aragon with *Le Paysan de Paris*. Aragon explained: 'I was seeking . . . to use the accepted novel-form as the basis for the production of a new kind of novel that would break all the traditional rules governing the writing of fiction, one that would

be neither a narrative (a story) nor a character study (a portrait), a novel that the critics would be obliged to approach empty-handed, without any of the weapons which customarily help them exercise their stupid cruelty, because in this instance the rules of the game would all have been swept aside'. Moreover, as he confessed, 'it was not a question simply of disarming the critics ... I was writing this novel-that-was-not-a-novel – or at least I thought of myself as writing it – to *demoralize* my [surrealist] friends, who were so busy proclaiming themselves the mortal enemies of the novel in every form while still indulging in reading matter such as Lewis's *The Monk* or Restif de la Bretonne' (*Paris Peasant*, pp. 13, 14).

Basing the book on two minor Parisian landmarks, the Passage de l'Opéra and the Buttes-Chaumont, Aragon traces what he calls an 'illusionistic landscape'. The immediate reality of his surroundings becomes both an inspiration and a catalyst. While he cannot subscribe to the naturalist's conviction that detailed description has a validity of its own and adequately captures an essential truth he detects in the concrete details of his environment not merely intimations of a more fundamental reality but a tension which itself creates that reality. The facticity of the novel, which so repelled Breton, is made the springboard which takes Aragon beyond 'the frontiers of reality'. As he insists, 'I do not subscribe to the idea that the world can be had for the asking. This hand-kerchief saleswoman, this little sugar bowl which I will describe to you if you don't behave yourself, are interior boundaries of myself, ideal views I have of my laws, of my ways of thought, and may I be strung up by the neck if this passage is anything else but a method of freeing myself of certain inhibitions, a means of obtaining access to a hitherto forbidden realm that lies beyond my human energies.' The Passage de l'Opéra becomes an image of the 'passage' connecting the conscious and sub-conscious, the concrete and the insubstantial, as Aragon sets about the task of 'discovering

the face of the infinite beneath the concrete forms which were escorting me, walking the length of the earth's avenues' (*Paris Peasant*, pp. 101, 130).

The book deliberately frustrates our expectation of narrative structure. Breaking off a description of an expedition which he had conducted to the Buttes-Chaumont, in the company of André Breton and Marcel Noll, in order to indulge in an ironical account of human foibles, he refuses to pick up the threads of narrative. Instead of satisfying demands for a linear plot or paying proper attention to the minutiae of physical reality, he begins to assault the reader: 'shall I now simply carry on with my mendacious description of a park through which three friends are wandering one evening ... You think, my boy, that you have an obligation to describe everything. Fallaciously. But still, to describe. You are sadly out in your calculations. You have not enumerated the pebbles, the abandoned chairs ... All these people who are wandering. What on earth you are driving at may as well get lost in the details, or in the garden of your bad faith. Readers, right dress! ... Quick march! They have followed me, the idiots ... I shall never finish this book which you are really beginning to like.' This is no Dadaist provocation. Aragon is simply insisting that critical responses rooted in the conventions of the realist novel can offer little insight into a work which concerns itself with 'tracing an image of the mind'. The book parodies the craft of the 'fiction' writer but does so in order to discover the lyrical insights of a mind released from the established responsibilities of the genre. The result is often prose of considerable beauty which combines the surrealist's relentless pursuit of the marvellous with an uninhibited exultation in the potential of language as well as the pregnant possibilities of life: 'At last each particle of space is meaningful, like a syllable of some dismantled word. Each atom suspends here, as a precipitate, a little of its human faith. Each breath of wind. And the silence is a mantle that is unfurling. See

these great folds of stars. The divine brushes the illusory lightly with the tips of its slender fingers. Breathes out its delicate breath upon the window-pane of the abyss. Cables to anxious hearts its magic message: *Patience stop mystery in motion* and, betrayed, reveals itself to the glimmers of light. The divine communes with itself in the depths of a caress: the whole air of the landscape is mingled with the idea, the whole air of the idea trembles at the least breath of wind'. As he explains, 'I was filled with the keen hope of coming within reach of one of the locks guarding the universe: if only the bolt would suddenly slip.' Here is the essence of the surrealist's quest, a quest in which the 'surrealist realism' of Aragon (a realism which became progressively less surrealist and more socialist) has, arguably, as important a part to play as the unpredictably brilliant images of automatism (*Paris Peasant* pp. 194, 182, 128).

It is tempting to regard surrealism as synonymous with the automatic method. Breton, in fact, implies as much in the First Manifesto, and it was notable that those who attained to it, both in literature and art, received the most enthusiastic praise. But this was only one method, as the lyrical poems of Breton and Éluard or the graceful arabesques of Dali and Tanguy attest, in the whole battery of techniques to subvert the rational. Breton's poem, 'La mort rose' (Rosy Death), for example, orchestrates striking individual images to create an elegiac tone in a manner which seems far removed from the spontaneous creations of automatism:

> The winged octopuses will guide for the last time the
> ship whose sails are made of this day hour by hour
> It is the unique watch after which you will feel the
> white and black sun rising in your hair
> From the cells will ooze a liqueur stronger than death
> As contemplated from the heights of a precipice
> The comets will lean tenderly on the forests before
> smashing them down

And all will pass into the indivisible love
If ever the motif of rivers disappears
Before it is completely dark you will see
The great pause of silver
On a peach tree in blossom will appear the hands
That wrote these lines and they also will be spindles of
 silver
Also swallows of silver on the loom of the rain
You will see the horizon opening and suddenly the kiss
 of space will come to an end ...

(Selected Poems, p. 37)

The basic function of automatism was to challenge Aristotelian and Cartesian assumptions about the nature of art and reality and to restore vitality to a language which had been drained of it by propaganda and the utilitarian demands of daily usage. For Breton it was no part of the artist's function to mimic nature, or to allow himself to be circumscribed by logic and rationality, and no part of the purpose of language to be a functional tool. The true purpose of art and indeed of life itself was to expand our definition of reality until it included the marvellous.

Yet in time it became apparent that the automatic process had its limitations. In the first place the clear distinction between conscious and unconscious was never one that could be maintained with any real conviction, nor were the texts produced entirely convincing in their claims for authenticity. By 1932 Breton was ready to confess that a minimal amount of rational control had marked virtually all automatic writing and was even prepared to grant that such control might indeed have a role to play – a far remove from the positive assertions of the First Manifesto. He also confessed that the powerful images of automatism, which in genuine texts occur with irritating infrequency, and whose original purpose had been to fire the imagination and demonstrate the possibility of synthesis, had proved to have an attraction of their own – a notion

which, once accepted, allowed the whole paraphernalia of literary criticism back in and reduced surrealism to the status of the literary *avant-garde*. It was certainly true that there was an observable law of diminishing returns in proliferating automatic texts. Even the marvellous, it seemed, could become mundane; even variety can lack variety if sustained too long. Increasingly Breton came to feel that automatism might have served its purpose. In 1933 he even went so far as to admit that the history of automatic writing had been 'a constant misfortune' (Jean, p. 126).

Surrealism, Breton had asserted in the First Manifesto, was dictation 'by thought, in the absence of any control exercised by reason, exempt from any aesthetic or moral concern' (*Manifestoes of Surrealism*, p. 26). The inadequacy of this stance on a moral plane was demonstrated in the rapid move towards political commitment; on an aesthetic plane by the emergence of surrealist art. In retrospect it seems obvious that painting constituted a perfect medium for the manifestation of the subconscious but it was equally clear that it could scarcely purge itself entirely of aesthetic purpose. It might be a 'lamentable expedient', as Breton called it, but it clearly had a vital role to play whether it took the form of the weird dream images of Chirico, Magritte, Dali and Tanguy, or the automatic drawings of Masson and Miró which had largely preceded them. In many ways surrealist painting was close to surrealist writing. The automatic technique was utilized, though from the beginning with a degree of conscious manipulation which was officially absent from the early written form. As Miró explained, 'Rather than setting out to paint something. . . . I begin painting and as I paint the picture begins to assert itself, or suggest itself under my brush. The form becomes a sign for a woman or a bird as I work. . . . The first stage is free, unconscious' (*Rubin*, p. 68). It was a style which clearly deviates from pure automatism but which, more significantly in the case of Miró, Ernst and Masson, sharply and deliberately contrasted with the conscious

application usually associated with the craft of painting, and in the case of Chirico, Dali and Tanguy deliberately parodied the elegant precision of classical art.

The mockery of classicism which is implied in Chirico's stately cities inhabited by wandering nudes and subversive sexual objects is continued in the realistic technique but fantastic subject-matter of Magritte, Tanguy, Dali and Delvaux. In 'Personal Values' (1952) Magritte achieves his bizarre effects, as Lewis Carroll had in *Alice in Wonderland*, by a deliberate distortion of scale. A glass, a comb, a shaving-brush, a pin cushion, a match, fill a room whose walls are formed by the sky (a combination reminiscent of Apollinaire). In a virtual prototype of surrealist technique the rational mind is turned against itself. The apparent realism of the objects is shown to be illusory and the picture itself can only be 'understood' as a fantasy. Similarly, the nudes which inhabit the paintings of Chirico and Delvaux are both evidence of the surrealist's fascination with the erotic and comments on the apparently realistic settings in which they appear. Thus the trams passing along an ostensibly realistic street, in Delvaux's 1946 painting, 'Le Train Bleu', are transformed by the incongruous presence in that same street of several semi-nude women in classical poses. Their sexuality subverts the realism of the rest of the painting in a literal way – the shape of the women's breasts being repeated in the street lamps, the concrete bollards enclosing iron gates and the headlights and sidelights of the trams themselves. The hard, mechanical reality of the vehicles and the physical surroundings is thus softened and undermined by this anthropomorphic dimension, and the scene aspires to the condition of a dream as the driverless trams are seen immobile in the moonlight, their functional qualities drained from them. This quality of a dream image, captured and frozen, is common to a great deal of non-automatic surrealist art, from Tanguy's desert world full of statuary-like weird plants and animals instantaneously calcified, to Dali's static

wasteland landscapes, which he himself called hand-painted photographs.

Dali saw his central aim as the total discrediting of the world of reality – a somewhat different objective, on the surface, from that which Breton had identified but reminiscent of Aragon's provisional position. Yet Breton had also spoken of the 'superior reality of the dream' in 1924, and while he moved away from this absolutist stance Dali set out to document his assertion by undermining the solidity of the 'real'. In Dali's world watches become flexible, their functional quality destroyed; the human form constantly threatens to disintegrate. Yet, despite this collapse of form, the technique, disturbingly, remains that of photographic realism. The spectator's rational assumptions are turned against himself. For if Dali's world is real, as its surface texture would suggest, then our definition of reality must be radically altered. If, on the other hand, it is not real then we must begin to distrust those senses which suggest that it is and that process of deductive reasoning which seems to lead only to paradox. As Dali explained, 'my whole ambition in the pictorial domain is to materialize the images of concrete irrationality with the most imperialistic fury of precision – in order that the world of the imagination and of concrete irrationality may be as objectively evident, of the same consistency, of the same durability, same persuasive, cognitive and communicable thickness as that of the exterior world of phenomenal reality. . . . The illusionism of the most *arriviste* . . . art, the usual paralysing tricks of *trompe-l'oeil*, the most . . . discredited academicism, can all transmute into sublime hierarchies of thought' (Rubin, p. 111). Rationality and reason stand routed, for the imagination alone, it seems, can penetrate the cypher of existence. But this subversive art clearly deviates from the spontaneous image which one associates with the automatic process. It represents a move from the arbitrary brilliance of liberated language and lines to the strange illogicalities of the dream.

Automatic writing was, of course, scarcely a new phenomenon. Not only had Nerval created works while in what he called a 'supernaturalist' dream state, taking the phrase from the German romantics, but spiritualists had long relied on messages written by mediums whose function, like the surrealist writer's, was to act as agent rather than principal. It is hardly surprising, therefore, that both dream narrations and interrogations under trance, began to play a role in the pursuit of non-rational revelations. The year 1924 saw the publication of Aragon's *Une Vague de rêves* while *La Révolution Surréaliste* dedicated a whole edition to the phenomenon of dreams. Robert Desnos rapidly developed the ability to fall asleep under practically any circumstances (once, reportedly, threatening Éluard with a knife while asleep) while Breton recorded, with obvious approval, the practice which the poet Saint-Pol-Roux had developed of leaving a notice on his door while sleeping which read, 'The Poet Works'. Following Freudian practice, dreams were narrated and written down. However, as a method of subverting rational control, this technique proved disappointing. Faulty memory, itself perhaps a form of censorship, together with the inevitable imposition of form and structure on visions whose essence lay in their irrationality, meant that dreams recollected in tranquillity often lacked precisely that quality which made them valuable. The trance proved no more effective and actually turned out to be dangerous when a group of surrealists, under this influence, decided to commit suicide by hanging.

Despite the spiritualist overtones of some of these experiments the surrealists were not concerned with contacting the afterlife or communicating with spirits. They wanted to demonstrate the inadequacy of conscious reality and to realize the full potential of language. But there is a sense in which this battery of techniques for creating spontaneity constituted an essential contradiction in terms. It seemed to represent a confession of doubt on the part of

men who believed that the imagination had the power to exert itself in the face of reason and logic. But in an age when imaginative insight was blunted by the assertive power of materialism such dependency was perhaps explicable.

If automatic writing, dream narrations and trance-induced texts were proved fallible, the surrealists simply came to rely more heavily on two central principles: on the heroically subversive nature of chance, arbitrary, illogical and unpredictable, and on the irrational power of human passion, vital, intuitive and evocative. Where the poet is usually at pains to select a specific word, to impose a particular rhythm or structure, the surrealist allows the mechanism of chance to determine the form of his work and the volatile nature of the subconscious to create iridescent verbal effects. Lewis Carroll's Humpty Dumpty made words mean whatever he wished. The surrealist does not exercise even this control. For him words are free, and their force and vigour, as well as their evocative power, lie precisely in the extent to which they evade imposed meaning, combining with one another in obedience to no laws of rational discourse or poetic fancy. He surrenders autonomy to the word. In this respect the so-called surrealist games were especially important. These adaptations of children's party games were designed to evade any possibility of conscious control. This was achieved by means of group compositions in which each contributor was kept in ignorance of the contributions of others. The most famous of these was *Le Cadavre exquis*, a variation of the game of 'consequences' which derived its name from the first sentence so created. Each individual wrote one word, folded the paper, and passed it to the next person. The first sentence produced in this way read: 'The exquisite corpse will drink new wine.' The game of course conforms to the central method of surrealism by bringing together disparate ideas which, in this case, are not even united as products of a single intellect. Yet curiously the most effective examples are frequently those which retain a

vestigial rational connection. The 'if', 'when' game, played by Yves Tanguy and André Breton, produced the following example: 'When the children will box their father's ears young people will all have white hair.' Similarly, the question and answer game produced, 'What is day? A woman bathing nude at nightfall' and 'What is absence? Calm, limpid water, a moving mirror' (Levy, pp. 45–46). Nevertheless chance came to play an increasingly important part in surrealist activities, and particularly in the concern with surrealist objects in the thirties.

The surrealist fascination with eroticism was largely a product of Freudian influence. After all, Freud's assertion of the central role of sexuality in human affairs could itself be seen as a direct challenge to the rationalist assumptions of the previous centuries. Moreover, he emphasized not merely the existence of the subconscious but also its primary significance. Firmly rooted in the subconscious, sexuality acquired a validation which made it a major weapon in the surrealist armoury.

Freud felt that the repression of certain sexual impulses was both inhibiting and potentially traumatizing. The surrealists saw it as evidence of the crippling impact of a society which had learned to replace vitality and revelation with a stupefying respect for mechanical order, routine and respectability. The surrealists thus opposed the sterility and impassive restrictiveness of the world with desire – a word which for them included not merely sexual passion but the whole apparatus with which they sought to expand awareness. Sexuality was especially important because it drew attention to the spontaneous, the instinctual, and the intuitive and was a resource available to all. In submitting to sexual urges the individual was after all learning again that rational control had its breaking-point and that, as the surrealists never tired of repeating, fantasy was an attainable reality.

But the erotic was scarcely born with Freud. The Marquis de Sade's fearless celebration of freedom in the face of a brutally

intolerant society made him a natural martyr to the cause while his pursuit of anarchic licence in sexual matters showed his determination to plunge into the irrational. The same could be said to a lesser extent of Rimbaud and Apollinaire, the former making a point of reading erotic literature and the latter actually writing two pornographic novels. The erotic is by its very nature subversive. It reclaims an area of experience effectively denied by official culture. Pornography is not only an attempt to flout middle-class taste and standards; it is an experiment in testing the extremes of human sensibility in a society which values moderation above a truth which can only emerge from the frontier of experience.

The extent of the surrealists' commitment to the erotic is manifested by the paintings of Chirico, Ernst, Éluard, Hugnet and Svanberg, among many others, and by texts of a kind typified by Aragon's *Paris Peasant* or his stunningly entitled, *Le Con d'Irène*. It was Aragon, too, who claimed to see a 'surrealist glow' in the eyes of all women and certainly the surrealists set themselves up as the defenders of love in all its guises (with the exception of homosexual love which they denounced) and of women in particular. Love, which by the end of the twenties suffused surrealist literature, was a natural enough extension of their other interests. By definition it is concerned with the reconciliation, the mating, of opposites; it is an assertion of the naked forces which the surrealists were so intent on tapping; it is the antithesis of rational response. Indeed, as Éluard explains, to associate love with reason is to destroy it: 'In order to find for myself reasons for loving you, I have lived badly' (*Selected Writings of Paul Éluard*, p. 25). But love is not its own justification. As Breton explained, 'the act of love, just like the picture or the poem, is disqualified if, on the part of the person giving himself to it, it does not presuppose *entering into a trance*' (*An Introduction to Surrealism*, p. 154). Like automatic writing, the recollection of dreams, or hallucinations, it is a means to an end. Thus the discussions of love and sexuality which

the surrealists conducted in 1928 and 1929 were, essentially, exercises in method.

But, like Dada, surrealism was never simply a style or set of principles. It was an attitude of mind – a revolution in consciousness which affected far more than the form and substance of literary and artistic work. In 1938 Breton characterized the period then ending as the age of Lautréamont, Freud and Trotsky. The choice of icons was significant. Poetic insight, concern with the unconscious, assertion of the central role of the libido, political commitment, together formed the basic elements of his creed. The surrealists were not interested in the clinical application of Freud's theories. They did not want to restore individuals to 'sanity'. On the contrary, they saw madness as a key to perception and the reconciliation of opposites; they saw in the dream not evidence of undesirable neurosis or a neural memory of trauma but proof of the power and perception of the imagination unmediated by intellect. The distinction between the imaginatively and the concretely real (in Dr Johnson's sense) is, anyway, not one which the surrealists would accept. Breton indeed was tempted to grant a superior reality to the dream. Surrealism, in other words, reverses the point of Plato's metaphor of the cave, for the surrealist posits the existence of a race of men who have been tied in such a way that their eyes have seen nothing but the conventional realities of daily life. Suddenly one is released and shown the flickering shadows of a nether world in which the mundane becomes the marvellous. For the first time there is scope for the imagination, for the shadows cast on the wall are as ambiguous as they are arbitrary. But they too constitute reality – a reality expanded now to incorporate the visions of the unconscious, the disturbing insights provoked by chance and the rhapsodic mystery of love, seen not as sentimental anodyne but a passionate fusion of opposites. The man granted this insight is the surrealist poet. His function is to bring the good

news back to those still trapped with a savagely limited version of reality.

Surrealism was equally opposed to the prosaic and deterministic literal-mindedness of naturalism and the aesthetic self-consciousness of modernism. As Aragon explained 'the marvellous opposes what exists mechanically, what *is* so much it isn't noticed any more, and so it is commonly believed the marvellous is the negation of reality. This rather summary idea is conditionally acceptable. It is certain the marvellous is born of the refusal of *one* reality, but also of the development of a new relationship, of a new reality that this refusal has liberated' (Matthews, *French Surrealist Poetry*, p. 41). Aragon's reservation was an important one, for though the surrealists' commitment to tapping the resources of the unconscious implied a subversive attitude towards reality, their ultimate aim was not to subvert or even to transcend but to redefine reality in such a way as to incorporate both the conscious and subconscious world. They did not, as did the modernists, counterpose the ordered structure of art to the imminent chaos of the world; they pursued a vision of life which employed the iconography of apocalypse (Dali, Buñuel, Tanguy) to convey a sense of expanded reality rather than to express a sense of desperation.

Modernism was ushered in on the wave of nineteenth-century science, political thought and artistic experiment; the twentieth century seeing not only a change in manners but an alteration in our perception of reality. The modernist questions the nature of reality – our ability to *perceive* and *apprehend* it. And these are significant verbs. But vision does not come with the external eye. *In*sight, *in*tuition, the imagination are liberated in an attempt to penetrate to some essential truth. To this extent the impressionists, the expressionists and the surrealists all pursued essentially the same aim. The revolutionary immediacy of the realists – who were the first to confront directly the modern experience – was quickly supplanted and enriched by the indirection of a stylistic manner

which reflected the flux and complexity of a fragmenting world picture. Reality now becomes problematic: to Pirandello it is paradoxical, to Breton fantastic, to Robbe-Grillet precise, while to Genet it is perhaps finally unknowable.

Thus while surrealism can be seen, in painting, as a wedge driven between the two periods of abstract art, and, in literature, as a positive rejection of the excessively aesthetic purpose which underlies the various techniques of modernism, surrealism and modernism are not completely contradictory. It is arguable that the automatic drawings of Masson provide at least a tenuous link between the abstract art of the first decades of the century and the abstract impressionism of the period since World War II. Moreover, the verbal obsessions, the power of the image, even the concern with achieving a more precise, if expansive definition of reality, indicate the lines of force drawing surrealism into the modernist movement. The modernists had, after all, already recognized the existence and power of the subconscious, though, for the most part, they had conceived of it in decidedly prosaic terms.

But modernism is not merely a matter of style. It embodies a manner of looking at experience. It is associated with a sense of incompletion, with entropy and anomie and alienation – words significantly derived from science, psychology and political theory. Society is no longer seen as organic – the body politic. Now it is mechanical – the social machine. The image now, for Henry Adams in 1907 or for Eugene O'Neill in 1929, was the dynamo. The surrealist, however, is not trapped in a continuous doubt about the very terms of his existence and the nature of his own identity. He does not envisage a world in which anomie is a basic fact of life and the individual ineluctably hobbled by one social determinant or another. For the surrealist the conditions of life can and must be changed, though this transformation must never be limited to the details of sociological and psychological reality. Art, for the surrealist, is thus not a simple social corrective or a

strategy for evading an insistent reality, it is the means of provoking a fundamental revolution of consciousness. As Aragon explained, in *Paris Peasant*, 'the vice named *Surrealism* is the immoderate and impassioned use of the stupefying *image*, or rather of the uncontrolled provocation of the image for its own sake and for the element of unpredictable perturbation and of metamorphosis which it introduces into the domain of representation: for each image on each occasion forces you to revise the entire Universe' (*Paris Peasant*, pp. 78–79). This, and nothing less, was the task which the surrealists set themselves.

The influence of surrealism has been considerable (see J. H. Matthews 'Surrealism in the Sixties'), not only in France but throughout the world. The classic period of surrealism may have passed, but there are few countries untouched by its humanizing effect and few without individuals as committed to surrealism as Breton and Éluard had been. The impact of surrealism is observable in pop art's concern with the object, its fascination with photographic images and its attraction for linguistic games; in the central role of chance in the work of the abstract impressionists, of the creators of happenings, of musicians such as John Cage and La Monte Young, and of experimental novelists like the English B. S. Johnson and Alan Burns. It is observable, too, in the importance granted to improvisation and spontaneity and in the impact of Artaud's ideas in the theatre; it can be seen in the visual and verbal collages of Edward Albee's *Quotations from Chairman Mao Tse-Tung*. It is detectable in the language of the revolutionary and in the techniques of the writer and artist alike. To a generation seemingly as intent on changing consciousness as altering the structure of society, the ethos of surrealism, humane, iconoclastic, imaginative and international, seems more relevant and attractive than ever. It seems, in fact, to have genuinely affected the nature and tone of popular culture, as indeed has Dada, though Duchamp,

F

greatly admired by Andy Warhol among others, sees 'New Dada,' which they call New Realism, Pop Art, Assemblage, etc.', as 'an easy way out' which 'lives on what Dada did. When I discovered ready-mades', he objects, 'I thought to discourage aesthetics. In Neo-Dada they have taken my ready-mades and found aesthetic beauty in them. I threw the bottle-rack and the urinal into their faces as a challenge and now they admire them for their aesthetic beauty' (Richter, p. 200).

But in assessing the influence of surrealism it is always essential to distinguish between style and philosophy. Surrealism is not simply the striking image, the irrational phrase or the dream-like texture. These are methods. It is essentially concerned with liberating the imagination and with expanding the definition of reality. It is not concerned with presenting the coherent rationality of irrationality which one finds in Kafka and, despite Breton's acknowledgement of the seminal role of the gothic novel, it would be a mistake to regard surrealism, as de Sade regarded the gothic form, as essentially the realistic mode of a revolutionary age. Writing in 1800, de Sade remarked that 'there was no one who did not undergo more misfortune in five years than the best novelist could describe in a century; therefore hell had to be called in to help and interest, to find in nightmare merely what one knew ordinarily just by glancing over the history of man in this age of iron' (Gorer, *The Life and Ideas of the Marquis de Sade*, p. 63). The gothic romance thus becomes a version of realism in the same sense that Breton was to accuse the stream of consciousness technique of being in the early years of the twentieth century. Breton's admiration for *The Monk* was for its freedom of imagination not for its factitiousness for which, as he made clear in rejecting the novel-form, historically the genre most closely associated with realism, he had nothing but contempt. The surrealists, by definition, are concerned with expanding our definition of reality not with producing images commensurate with a disturbed era.

That, after all, implies an Aristotelian view of the function of art which, as we have seen, is ideally the very antithesis of surrealism, although, to be sure, dream narrations and automatic texts are not entirely divorced from the notion of psychological realism. Thus, suggestions that the modern novel, and in particular the modern American novel, from Nathanael West to William Burroughs and Kurt Vonnegut, is surrealist simply because its grotesque and violent images are an accurate reflection of a nightmare reality is to confuse style with purpose. It was no part of surrealist intention to refine the technique of naturalism. Breton set out to change consciousness not to reflect it. West, Burroughs and Vonnegut (Henry Miller is, one suspects, an exception) are basically the inheritors of the gothic tradition as defined by de Sade; they have more in common with Poe, Hawthorne, Melville and Bierce than Breton, Aragon and Soupault.

A similar misconception underlies suggestions that the comedy of the Marx Brothers, the bizarre insights of E. E. Cummings or, indeed, the whole phenomenon of the theatre of the absurd are a direct product of surrealism. Martin Esslin's suggestion that W. C. Fields was a 'brilliant surrealist comedian' (Esslin, p. 287) is thus to confuse a skilful use of the non-sequitur, the pun and the disconcerting assertion with the serious intent of surrealism; again style is mistaken for purpose. Fields or more especially the Marx Brothers, whom Artaud and later Ionesco greatly admired, were part of a clearly definable tradition of vaudeville which had none of the pretensions of Breton and his confrères. And it is this tradition which E. E. Cummings draws on in his satirical play *him* – a tradition which indulged in irrational comic patter and excruciating linguistic games long before the surrealists adopted them.

The relationship between the theatre of the absurd and surrealism is more complex than would at first appear. Up to a point both movements share a common heritage in the grotesque, the fantastic and the nonsensical. Both could point not only to Jarry,

to Lewis Carroll and to Edward Lear but even to the visionary paintings of Bosch and Bruegel. But where the surrealists saw a potential instrument for provoking an imaginative revaluation of experience in such disconcerting images the absurdists saw expressionistic symbols – distorted images of an equally distorted world. Nevertheless there were points of contact. Beckett translated poems by Éluard and Breton, Adamov befriended Artaud, and Ionesco confessed to a fascination with surrealist poetry. When Breton and Péret saw Ionesco's early plays they even hailed him as a surrealist writer. But Ionesco himself has been careful to distinguish between his work and what he took to be the spontaneous overflow of surrealist prose. 'I fully realized that liberation can come only when there is a genuine appreciation of what has been revealed and the ability to control these revelations from the supra-conscious world. I believe there must be in a writer, and even in a dramatist, a mixture of spontaneity, unawareness and lucidity; a lucidity unafraid of what spontaneous imagination may contribute. If lucidity is required of him, *a priori*, it is as though one shut the floodgates. We must first let the torrent rush in, and only then comes choice, control, grasp, comprehension' (*Notes and Counter Notes*, p. 124). The distinction was not a real one for, as we have seen, the surrealists had long since abandoned their purist stance on automatism. The real difference, therefore, is not so much one of style as of philosophy, for the Ionesco who has said, 'I have no other images of the world except those of evanescence and brutality, vanity and rage, nothingness or hideous, useless hatred' and who has characterized human existence as 'vain and sordid fury, cries suddenly stifled by silence, shadows engulfed for ever in the night' (Esslin, p. 85), has little in common with the expansive vision and political optimism of the surrealists. The surrealist assumes that one can change the world; Ionesco, as Kenneth Tynan protested, saw man as impotent to alter even his own immediate circumstances. The absurd is not concerned with

the vitality implicit in chance, eroticism and the vision of the subconscious; it details the loss of meaning, the shrinking horizon of human potential. Language is not magical and inspiring; it is a desperate defence against truth; it is a façade and finally, it is the self-deceit on which he impales himself.

In defining the absurd, Camus identified an irreconcilable gulf between man and the world – an absurdity which arose from man's aspirations and the world's consistent denial of those aspirations. This is also Beckett's vision. In *Endgame* Clov picks up objects lying on the ground. He is, he explains, 'putting things in order' because 'I love order. It's my dream.' The irony lies in the fact that such order is impossible, or, if possible, resides in nothing more elaborate than the minimal structure imposed by the fact that we are 'born astride the grave'. If Ham and Clov or, in *Waiting for Godot*, Vladimir and Estragon, do seem to be taking part in a formalized drama the rules by which they operate are unknown to them and the gulf between aspiration and fulfilment unbridgeable. The only reconciliation lies, for the Camus of *Cross Purpose* and the Beckett of *Act Without Words*, in stoicism; no demands, no response. Not so for the surrealists. If the desert landscapes of Beckett's plays are in some respects reminiscent of Dali's, the nature of the irony is entirely different. Beckett's characters are mocked for assuming reality to be other than it is; Dali's for failing to realize that it is far more than it appears to be. Beckett is not concerned with the marvellous and the mysterious but with a harrowed realism. He taunts not rational but irrational man, who can blindly smile in the face of the sand which gradually engulfs him, in the ironically named *Happy Days*, or posit the existence of meaning and purpose where none exists (*Waiting for Godot*). Surrealism sees such irrationality as the source of spiritual renewal and existence as suffused with a potential which denies the apocalyptic implications of the absurdists. For the surrealist, humanity, commitment and even morality of a kind are not ironical illusions

spawned of desperation but valid responses to a world which is more expansive than Beckett could acknowledge.

The surrealists were not without a keen moral sense but their morality had no place for the hypocrisies and stultifying prudery of a society which placed social convention before the integrity of human response. Virtually alone they had protested at the cruelties of the Colonial Exposition of 1931, in which natives were exhibited like animals to bolster the sense of French Imperial power, and they continued to condemn injustice and brutality wherever they found it. To the surrealist a passionate blow will always be superior to calculated cruelty, the spontaneous gesture, in art as in life, better than premeditated design. In an age growing daily more materialistic, in a society which increasingly surrenders its fate to science and technology and in an environment which daily seems more hostile to those who so carelessly create it, the humanizing commitment of the surrealists becomes ever more attractive. The marvellous still has a role to play in explaining man to himself and in opposing the arrogant assumption that one can ever measure the stature of man and the extent of his universe. As Aragon asked, in *Paris Peasant*, 'can the knowledge deriving from reason ever begin to compare with knowledge perceptible by sense? No doubt the number of people crass enough to rely exclusively on the former and scorn the latter are sufficient in themselves to explain the disfavour into which everything deriving from the senses has gradually fallen. But when the most scholarly of men have taught me that light is a vibration, or have calculated its wavelengths for me, or offered me any other fruits of their labours of reasoning, they will still not have rendered me an account of what is important to me about light, of what my eyes have begun to teach me about it, of what makes me different from a blind man – things which are the stuff of miracles, not subject matter for reasoning' (pp. 22–3). Herein lies the essence of surrealism and the guarantee of its continuing relevance.

Select Bibliography

The following bibliography can, of course, only include a brief selection from the many books and articles spawned by Dada and Surrealism. I have included only those works at present available in English. For a more complete bibliography of French Surrealism see Gershman's book listed below.

ANON, *Cinquant' Anni a Dada, Dada In Italia, 1916–1966*, Milan, 1966.

ALEXANDRIAN, SARONE, *Surrealist Art*, trans. Gordon Clough, London, 1970.

ALQUIÉ, FERDINAND, *The Philosophy of Surrealism*, trans. Bernard Waldrop, Ann Arbor, 1969.

ARP, JEAN, *On My Way*, New York, 1949.

ARAGON, LOUIS, *Paris Peasant*, trans. Simon Watson Taylor, London, 1971.

BALAKIAN, ANNA, *Literary Origins of Surrealism: A New Mysticism in French Poetry*, London, 1967.

BARR, ALFRED, JR, *Fantastic Art, Dada, Surrealism*, New York, 1936.

BRETON, ANDRÉ, *What is Surrealism?*, London, 1936.

BRETON, ANDRÉ, *Manifestoes of Surrealism*, trans. Richard Seaver and Helen Lane, Ann Arbor, 1969.

BRETON, ANDRÉ, *Selected Poems*, trans. Kenneth White, London, 1959.

BRETON, ANDRÉ, *Nadja*, trans. Richard Howard, New York, 1960.

BROWDER, CLIFFORD, *André Breton: Arbiter of Surrealism*, Geneva, 1967.

CARDINAL, ROGER, and SHORT, ROBERT, *Surrealism: Permanent Revelation*, London, 1970.

CAWS, MARY ANN, *The Poetry of Dada and Surrealism*, Princeton, 1970.

DURGNAT, RAYMOND, *Luis Buñuel*, London, 1967.

ÉLUARD, PAUL, *Selected Writings of Paul Éluard*, trans. Lloyd Alexander, London, 1952.

FOWLIE, WALLACE, *Age of Surrealism*, London, 1957.

GASCOYNE, DAVID, *A Short Survey of Surrealism*, London, 1935.

GELDZAHLER, HENRY, *American Painting in the Twentieth Century*, New York, 1965.

GERSHMAN, HERBERT, *A Bibliography of the Surrealist Revolution in France*, Ann Arbor, 1969.

JEAN, MARCEL, *The History of Surrealist Painting*, trans. Simon Watson Taylor, London, 1960.

KNAPP, BETTINA L., *Antonin Artaud: Man of Vision*, New York, 1969.

LEMAITRE, GEORGE, *From Cubism to Surrealism in French Literature*, New York, 1967.

LEVY, JULIEN, *Surrealism*, New York, 1936.

LEIRIS, M. and LIMBOUR, G., *André Masson and his Universe*, London, 1947.

MATTHEWS, J. H., 'Surrealism and England', *Comparative Literature Studies*, I (1964), pp. 55–72.

MATTHEWS, J. H., *An Introduction to Surrealism*, Pennsylvania State University Press, 1965.

MATTHEWS, J. H., *Surrealism and the Novel*, Ann Arbor, 1966.

MATTHEWS, J. H., *An Anthology of French Surrealist Poetry*, London, 1966.

MATTHEWS, J. H., 'Surrealism in the Sixties', *Contemporary Literature*, XI, ii (Spring, 1970), pp. 226–42.

MATTHEWS, J. H., *Surrealist Poetry in France*, Syracuse, 1971.

MOTHERWELL, ROBERT, ed., *The Dada Painters and Poets: An Anthology*, New York, 1951.

MYERS, JOHN BERNARD, 'The Impact of Surrealism on the New York School', *Evergreen Review*, No. 12, pp. 75–85.

NADEAU, MAURICE, *The History of Surrealism*, trans. Richard Howard, London, 1968.

PAZ, OCTAVIO, *Marcel Duchamp or the Castle of Purity*, London, 1970.

RAY, PAUL C., *The Surrealist Movement in England*, London, 1971.

RAYMOND, MARCEL, *From Baudelaire to Surrealism*, London, 1970.

RICHTER, HANS, *Dada: Art and Anti-Art*, trans. David Britt, London, 1965.

RUBIN, WILLIAM S., *Dada, Surrealism and their Heritage*, New York, 1968.

VERKAUF, WILLY, ed., *Dada: Monograph of a Movement*, Teuffen, 1957.

WALDBERG, PATRICK, *Surrealism*, London, 1965.

WILSON, EDMUND, *Axel's Castle*, New York, 1931.

OTHER WORKS CONSULTED

BERGSON, HENRI, *Creative Evolution*, trans. Arthur Mitchell, London, 1913.

ESSLIN, MARTIN, *The Theatre of the Absurd*, New York, 1961.

GORER, GEOFFREY, *The Life and Ideas of the Marquis de Sade*, London, 1965.

HEMINGWAY, ERNEST, *A Farewell to Arms*, New York, 1929.

IONESCO, EUGENE, *Notes and Counter Notes*, trans. Donald Watson, London, 1966.

MATTHIESSEN, F. O., *The American Renaissance*, Oxford, 1968.

Index